CARLA RAE JOHNSON
LAURIE STEINHORST

SECOND
EDITION

DRAW!

Kendall Hunt
publishing company

Cover image courtesy of Xiaojing Dong.

Kendall Hunt
publishing company

www.kendallhunt.com
Send all inquiries to:
4050 Westmark Drive
Dubuque, IA 52004-1840

Contents

Preface

This is not a definitive text on drawing. We have written this book for our community college students who inspire us daily with their commitment to learning, their drive to improve their skills, their passion for making art, and their willingness to work hard to achieve their goals. We have found drawing students at Westchester Community College to be among the best we have ever taught. This book is dedicated to them.

A Note to Students Using This Textbook

We have written this book with you in mind. This is a very basic text designed to provide you with a "what, why, and how" introduction to drawing. You will find the reading to be straightforward and uncomplicated. In class we will undoubtedly provide you with additional sources of information by recommending books and other textbooks for you to read and Web sites for you to visit. These will allow you to see drawings by master artists and contemporary approaches to making drawings that will enrich your understanding of drawing processes and possibilities far beyond the scope of this book.

We encourage you to look at drawings, only a small number of which are in this book. We may augment what you find in this book with more examples of student drawings, master drawings, and contemporary drawings. We also encourage you to look more carefully at the world around you. Some chapters in this text will provide you with specific methods of seeing that may be new to you. It is our hope that these will open your eyes to new ways of seeing, more careful observation, and a deeper understanding of the visual experience.

A simple index of vocabulary has been provided to help you find definitions of terms in the margins of each chapter. You can access this quick and helpful reference if/when you forget or are confused about the drawing vocabulary we use in class.

We have also provided appendices that include "tear sheets" for your use. There are sketchbook pages and thumbnail sketch pages for your use in preparing for each of your drawing assignments. There are value-scale pages (see p. 47 for an explanation of value-scales) designed to give you practice in creating values in a variety of drawing media.

We hope you enjoy this book, and we hope it is helpful to you as you embark on your quest to observe and draw the visual world around you.

A Note to Instructors

Instructors who use this textbook will want to augment the illustrations (which include only instructional diagrams and student drawings) with their own collection of masterworks, specific examples, and drawings by contemporary artists.

Acknowledgements

We would like to thank those who have helped us bring this book to the shelves! First and foremost, we are deeply indebted to the contributing student artists whose drawings are found on the pages of this book. Not all **art majors**, the students whose drawings you will see on the following pages are definitely **artists**! As their teachers we are constantly impressed with the drawings produced by majors and non-majors, alike. Their dedication, passion, and unique visions continue to inspire us year after year.

We want to acknowledge the work of our assistant, Ana Santos, a Westchester Community College graduate who took on the task of contacting current and former students to get permission to use their drawings in the first edition of our book. Without Ana's organizational skills, hard work, and efficiency, we would never have been able to include so many fine illustrations. Along with other former students, Marion Bonner, and Marbel Canseco, Ana also modeled for many of the demonstration photographs.

Our faculty, staff, and administrative colleagues at the college have provided essential help and support. Special thanks go to Professor Matt Ferranto for his advice on cover design. Thanks also go to Professor Roberta Perry-Mapp and Dr. Melissa Hall both of whom worked with us closely helping us design the drawing curriculum that is highlighted in this text. Professor Claudia Cardoso provided invaluable technical and logistical support. Our Computer Technician, Kerrie Newell, helped with documentation and image files. Our thanks to Claudia and Kerrie! For the second edition, Westchester Community College photography major, Kyle Clohessy provided photography assistance for which we are grateful.

We would also be remiss were we not to thank the dedicated faculty who teach drawing at Westchester Community College. Their commitment to students, their energy, and their creative contributions to the program have all been invaluable to the drawing course on which this book is based.

Finally, we want to express our gratitude to the representatives of Kendall-Hunt who worked with us to revise and update our original book for this second edition.

Chapter 1

Introduction

This text provides an introduction to the basic concepts and skill building necessary when learning to draw from direct observation. In addition to the important elements of composition, value, sighting, positive and negative space, and mark-making, it also deals with materials, critiques, and general studio procedures.

You must learn to see before you can learn to draw. Learning to see requires that you move past assumptions, drawing what you see and not what you think you see. Although this may seem like a simple concept, it can prove to be one of the more difficult challenges for the beginner. We have become accustomed to seeing only what is necessary, not seeing things in detail but seeing only the essential elements necessary for our immediate task. Beginning students must learn to look at their subject as though seeing it for the first time, without preconceived notions about what they "know" it looks like. This requires students to trust their eyes, allowing the eyes to inform the hand. Students must learn to slow down and be patient to observe precisely and accurately, recording information directly from what they observe.

Drawing, as a skill, can be learned. But drawing can be so much more than just a skill. Drawing is a fundamental visual language that can be an effective means of communication and self-expression. The beginning student must build a basic understanding of composition, value, line, and form. The systematic skill-building approach outlined in this text is meant to serve as the building blocks necessary for each student to begin developing his or her own voice. This approach to drawing is intended as a means to an end. Once discipline, patience, close observational skills, and a solid technical base are established, students will have the facilities to create drawings that communicate effectively and creatively and can act as a means of self-expression.

Materials

Charcoal drawing paper – a heavier-weight, more durable paper than newsprint. Charcoal paper has a pronounced *tooth* (texture) that helps to receive and hold the charcoal. This paper can handle a lot of erasing

Newsprint – a lightweight, inexpensive paper. It yellows and disintegrates quickly so it is only to be used for working or 'throw away' drawings. Good for use with charcoal or soft pencil.

Composition: the organization of visual elements on a two-dimensional surface.

Value: the degree of lightness or darkness.

Sighting: a system of measuring proportions and finding angles of planes moving into space that relies on vision.

Positive space: the objects you are drawing.

Negative space: the space between objects or the empty space in a drawing.

Critiques: a group discussion that involves critically analyzing a work of art for the purpose of better understanding the strengths and weakness of the work.

FIGURE 1–1

Photo Courtesy of Kyle
Clohessy

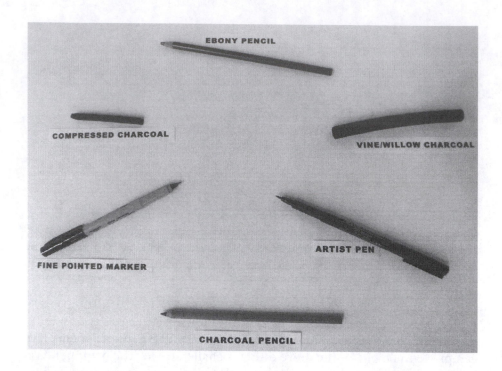

Vine/Willow charcoal – a very soft charcoal that is flexible and easy to erase. These qualities make it a perfect material for certain types of drawing and to use at the beginning of a drawing when a lot of erasing takes place. It comes in thin sticks with different densities (soft, medium, and hard). It is best to purchase vine charcoal with a thickness no less than finger width; when the soft charcoal gets thinner than this, it breaks very easily.

Compressed charcoal – a dense charcoal that can easily achieve a range of value that includes rich, velvety blacks. This makes it an essential material for value drawing. It is harder to erase than vine charcoal but still a great material for beginners because of its flexibility and forgiving properties. Compressed charcoal comes in large chunks or sticks, either rounded or squared, with different densities (soft, medium, and hard).

Fine pointed marker – a black ink marker with a very small point. This does not erase.

Ebony pencil – pencil with a very soft graphite making it easy to arrive at very dark values and to blend and smear.

Artist's pen – a marker that has a flexible, pointed nib. Good for blind and semi-blind contour line drawing because of its ability to create varying line weight. With soft pressure the line is thin; with hard pressure the line becomes thicker.

Charcoal Pencil – a wooden pencil with charcoal (in place of traditional graphite). It can be sharpened to produce a fine point, great for creating a defined edge to forms.

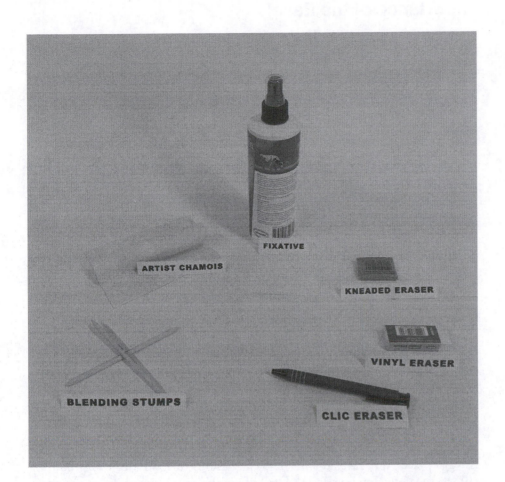

FIGURE 1–2
Photo Courtesy of Laurie
Steinhorst

Chamois– a thin piece of suede used with charcoal. A chamois is a multipurpose tool and can be used to lighten, darken, and erase charcoal. A chamois loaded with charcoal can create a ground quickly and easily.

Fixative– comes in a spray can or pump spray and is used to "fix" or bond charcoal to the paper. A "workable" fixative allows additional layers of charcoal to be added to a drawing but does not allow erasing. Use any fixative after your drawing is completed. **Be very careful when using fixative as it can be a toxic material. Only spray outside or with good ventilation.**

Blending stumps – made from paper tightly rolled or compressed into a pencil-like form. Used for blending and smearing drawing materials. Blending stumps come in a wide variety of widths.

Kneaded eraser – a soft, pliable eraser, good for creating gradation of value.

Plastic/vinyl eraser – multipurpose eraser good with charcoal or graphite.

Click eraser – multipurpose vinyl eraser that comes in the shape of a ball point pen. The small tip makes it great for creating lines with the eraser and getting into small spaces.

Soft cotton cloth – good for blending charcoal without removing it (unlike a chamois).

Importance of the Easel

Standing at an easel is the best position for learning to draw. (Illustrations in Chapter 5 indicate the proper way to stand at an easel to draw.) There are many reasons why the easel is an important tool for the drawing student:

Picture plane: The surface on which a two-dimensional work of art is created.

- The upright structure allows the **picture plane** to remain at eye level and parallel to the artist while drawing. This perspective eliminates the unwanted distortions that occur when drawing while seated at a table.

- Standing at an easel requires an energetic participation from the artist. You are at attention in a way that you are not when seated. This physical engagement ensures a level of focused concentration critical to a successful drawing.

Angling and measuring technique: A system of measuring proportions and finding angles of planes moving into space that relies on vision (unlike linear perspective, which relies on a set of rules).

- The artist is able to stand at arms length from the drawing board, allowing for the full arm motion required for application of the **angling and measuring technique** described in Chapter 5.

- Standing at the easel encourages the use of a full arm gesture when drawing, unlike the wrist action that occurs when seated at a table. This allows the artist to begin seeing the larger elements in a subject and discouraging attention to unnecessary detail.

- It is much easier to back away from the drawing periodically when standing at an easel than it is when seated. Evaluating your drawing from a distance creates an alternative perspective that is helpful in perceiving any distortions or inaccuracies in the drawing.

Always place your easel at a 45-degree angle to the still life. You should be able to see your drawing and the still life with just a quick shift of your eyes.

FIGURE 1–3
Student demonstrating the correct positioning of the easel.
Photo Courtesy of Carla Rae Johnson. Model: Ana Santos

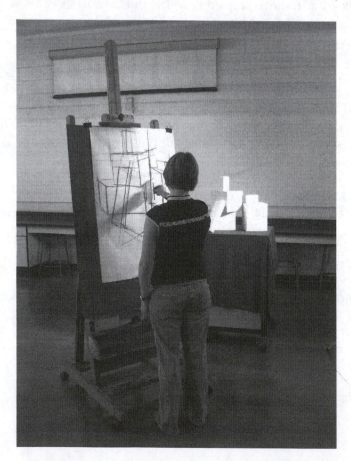

This allows you to constantly refer to the still life while drawing, always taking the information from what you see. Positioning your easel in this way will also eliminate having to move your feet to make visual comparisons between the still life and your drawing. Every time you move your feet, you are shifting your position in relation to the still life, therefore changing what you see. It is important to keep your feet planted in one spot, always looking at your subject from a consistent fixed position. The technique for returning to a fixed point of view will be presented in Chapter 5.

Critiques

Critiques are a valuable part of a studio class. In a critique, work is collectively hung in the classroom and a class discussion of critical analysis follows. Discussions can arise about the work itself, the technique or materials used, or perhaps the personal struggle the student had. Critiques are an important learning opportunity for many reasons:

- Critiques allow for a verbal exchange of ideas among students, analyzing not only the weaknesses in the work but also the strengths.

- Participating in a critique requires that students begin to use their art vocabulary and become more verbally articulate.

- In a critique you are able to evaluate your work and your ideas in the context of your classmates. You will find that your drawing looks very different to you when seen in comparison to your classmates' work.

- Participating in a critique requires that you begin to form opinions about work. It encourages you to recognize and understand your own sensibilities, which is important for the development of your own work.

- Listening to the comments from other students exposes you to the wide range of ways that art can be perceived and the wide range of possibilities in approaches. This opportunity can challenge your way of thinking and seeing and help you to form more sophisticated ways of looking and analyzing drawings.

- The critiquing process will help develop your ability to objectively analyze your own work. Moving outside the emotional attachment to your work and looking at it from a more analytical perspective will help to expand your work in new directions.

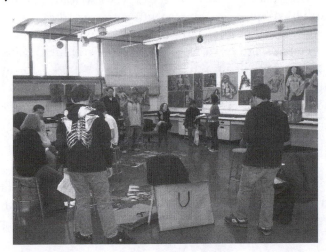

FIGURE 1–4

Students during a critique. Photo Courtesy of Laurie Steinhorst

There are two ways to look at and discuss drawings in a critique. Either approach is legitimate:

- You can look at the work subjectively. Look carefully at the drawings and notice which ones pull you in, which drawings appeal to you. Then ask yourself some questions about those drawings: What are the qualities that make those drawings more appealing than others? If this were your drawing, what would you do differently? How could you develop the drawing further?

- You can also look at the work objectively. Look carefully at the drawings and notice which ones fulfill the requirements of the assignment. Then ask yourself some questions about those drawings: What aspects of the drawings fulfill the requirements of the assignment? How could the drawing have fulfilled the requirements more thoroughly? Where does the drawing fall short of fulfilling the requirements of the assignment?

You may also discuss your own work in a critique. You can make a direct request for feedback on your drawing or discuss any problems or difficulties that you may have had.

Always approach the critique with an open mind. We grow by recognizing our weaknesses as well as our strengths. To move forward and grow as an artist, it is our weaknesses that we need to address. Think of the classroom studio as a safe place to make "mistakes," to challenge yourself, and to move outside of your comfort zone. Comments delivered in a critique are meant to be helpful and constructive; they should always be couched in a positive manner. Don't get defensive if your work receives criticism. A critique is not about passing judgment on the work but about critically analyzing the work. Remember, you're not alone. Everyone is nervous about presenting his or her work at one time or another. There is never one "correct way" to perceive a drawing. Everyone sees and responds differently to art. Your perception is as legitimate as the person sitting next to you, so don't be afraid to voice your opinion.

Still life: A collection of inanimate objects organized in a particular grouping for the purpose of painting or drawing.

Blind contour line drawing: A method of drawing in which the artist focuses on the subject, never looking at the paper, using one continuous line and never lifting the pencil off the paper.

Semi-blind contour line drawing: Similar method to blind contour line drawing with the exception that the artist may look at the paper but must stop drawing while doing so; the pencil can only move when looking at the subject.

Tips for Setting Up a Still Life

A strong **still life** can aid you in making a successful drawing. Still life objects can be simple everyday objects such as teapots, coffee cups/mugs, water glasses, wine glasses, wine bottles, bowls, fruit, books, toilet paper rolls, vases, house plants, boxes, tools, candlestick holders, umbrellas, and pots. The still life objects you choose will vary according to the objective of the drawing. For example, natural objects, baskets, and objects with a lot of natural curves and textures are preferable still life objects for **blind and semi-blind contour line drawings**. (See Chapter 3 for more information on contour line drawing.) Still life objects with solid form such as teapots, wine bottles, candlestick holders, books, and boxes are preferable objects for value drawings. Pay close attention in each chapter for suggestions on still life objects suitable for that topic.

Several general tips should help you in setting up a strong still life:

- Variety – make sure to use objects with a variety of different sizes and shapes. Use objects with a variety of characteristics—some that are tall, thin, short, wide, rounded, hard-edged, natural objects, man-made objects, etc.

- Height – create different heights in the still life. A box, perhaps covered with drapery, is an easy way to create height. Some of your still life objects can go on top of the box and some on the table on which the box is placed.

- Space – creating a physical space in your still life will help you to create the illusion of space in your drawing. Put some objects in front of others, lay some objects on their sides, or lean objects against each other, creating a path to help guide the viewer's eye.

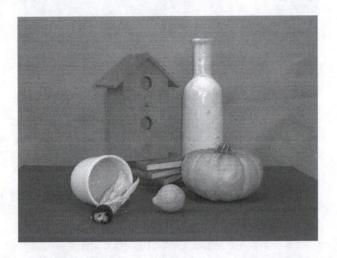

FIGURE 1–5
Still life with variety of different sizes and shapes
Photo Courtesy of Laurie Steinhorst

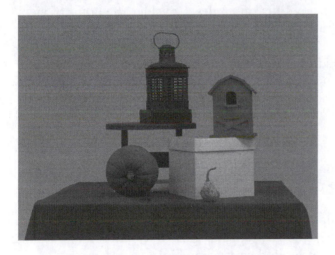

FIGURE 1–6
Still life with different heights
Photo Courtesy of Laurie Steinhorst

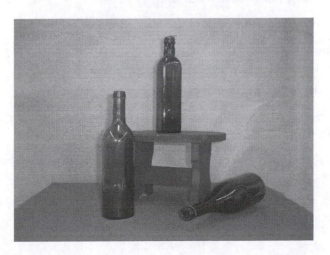

FIGURE 1–7
Still life creating a physical space
Photo Courtesy of Laurie Steinhorst

- Lighting – when working on a value drawing, your light source is very important. A single light source coming from one direction (as opposed to ambient light) helps to create obvious areas of darks and lights, making it easier to observe the value changes. Clip lights can be purchased inexpensively at any hardware store and are convenient to use.

FIGURE 1–8

Still life lit with a single light source coming from one direction
Photo Courtesy of Laurie Steinhorst

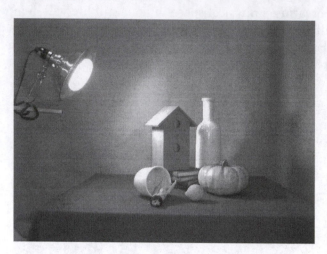

Don't overdo it. Don't create too much chaos. Your still life can be very simple. Remember it's not what you draw but how you draw it!

Before you begin drawing from your still life, walk around it and observe it from different angles. Consider the point of view from which you will draw. There are many possibilities: close-up, distant, aerial view (bird's eye), "worm's" eye view, or eye level. Each different angle or viewpoint will affect the impact of the drawing.

If you need to work from the still life over the course of a few days, make sure to find a quiet spot where your still life can remain set up and undisturbed.

Studio Classroom Procedures

To maintain a clean, pleasant, and safe working environment for all, please remember the following:

- Clean up after yourself. Pick up and discard any unwanted drawings, coffee cups, food wrappers, soda/water bottles, etc. Remember to dispose of bottles in the recycling bin!

- No iPods or listening devices are allowed during class.

- Cell phones should be turned off or set on vibrate. Take your phone outside the studio to answer a call.

- **Never** spray **fixative** in the studio or hallways.

- Avoid disruptive conversations. Take your personal conversations outside the studio.

- Be on time to class. When you are late, it is disruptive to the class and disrespectful to other students and to the instructor.

- Always come to class prepared with drawing supplies, completed homework assignments, and your textbook.

Fixative: A spray used to "fix" or bond charcoal to the paper. Be very careful when using fixative as some brands are toxic.

The classroom studio is a safe place to create, explore, and learn. When you walk through the door, you are a professional artist. Please conduct yourself accordingly.

Learn from Each Other

Learning to draw in a studio class environment has many advantages. The energy that a group of students offers and the exchange of different ideas and approaches are enormously helpful when learning to draw. Take a walk around the studio periodically during the drawing session and look at the work of the other students. This can be particularly helpful if you are having a hard time with your drawing or difficulty understanding a concept. Seeing the wide range of approaches and the illustration of concepts that are present in any classroom can be inspiring. When you find a drawing that you like, watch that student draw. Observe his or her process. Ask yourself what is happening in that drawing that you feel is lacking in yours. Don't be intimidated by students who have more experience; instead, learn from them. Listen to comments made during critiques, not only comments made about your work but also about other's work as well. Learn from each other!

Chapter 2

Composition

The study of drawing includes learning principles of good **composition**. Understanding these principles will help you to communicate to others through your drawings. Good compositions are the means by which artists create a sense of order out of the chaos in the world around them. Good compositions lend credibility to your drawings and to you as an artist. How you organize your composition is the creative element (or opportunity to be creative) in the drawing. In any given classroom, there will be as many different solutions to the compositional question as there are students in the room. The possibilities are endless.

Why Composition?

The principles of good composition, when put to use, can help improve your drawings in five important ways.

1. **Communication.** A strong drawing succeeds by communicating the artist's vision of a subject to an audience. To communicate clearly and effectively, your drawings need to be unified, interesting, and harmonious. When you apply the principles of good composition, you can create this unity, interest, and harmony.

2. **Order out of chaos.** We live in a busy, cluttered world with many demands on our attention and a multitude of beings and things surrounding us. Art is one part of our lives we expect to provide us with a respite from the everyday bustle and noise. An artist works to create a visual space that suggests order and harmony. This suggestion of order and harmony is created by using the principles of good composition.

3. **Credibility.** The principles of composition are, and have been, studied or learned by every practicing fine artist and designer. The average person knows very little about these principles. They are a "best-kept secret" that you will be learning as you learn to draw. Using these principles will lend credibility to your drawings. Your drawing instructors, art professors, fellow students, and other artists will be able to discern how well you understand these principles when they look at your drawings.

4. **Foundation.** This is your first college-level drawing class. Learning about composition is a vital part of the foundation you will need to succeed in making strong drawings **and** works of art or design in every other medium, including photography, painting, sculpture, crafts, and printmaking. This also includes digital media for graphic design, architecture, Web design, fashion design, product design, interior design, video, film, animation, and countless new disciplines for artists and designers

Composition: The visual elements; line, shape, volume, space, value, implied movement, and texture are the major visual elements that make up a drawing. Good compositions use these elements and the **principles of good composition** to create an interesting and unified whole. (See p. 14 for information about the principles of good composition.

5. **The big picture.** In the twenty-first century, we are barraged by visuals: images, advertisements, media hype, and text and video messages. Much of this is thoughtlessly and badly designed without unity and harmony. To know, understand, and be able to apply the principles of good composition to everything you create and everything you "put out there" means that the quality of the visual communication you transmit will be of a higher standard. It will enrich and reward, rather than distract and confuse, your viewers.

How Composition Works

- **Learning to make conscious decisions:** As a student artist learning to draw, you will be learning a new principle of composition with each assignment. You will apply previously learned principles as well as the new principle to each new drawing assignment you complete. In this way you will learn these principles and reinforce the learning over and over again. What may start out as a *conscious process*—thinking about applying a compositional principle—will soon become second nature to you. Soon you will be making decisions and applying these principles without having to think about them

 - **It's like learning to play a sport.** Anyone who's learned an athletic skill knows that one begins by practicing a move over and over again, doing it "just so" in order to reinforce the connections in the brain and the memory in the muscles.
 - **It's like learning to play the piano.** Anyone who has learned to play a musical instrument knows that one plays the scales again and again to get the fingering down. What starts out as a process of "thinking" about where your fingers go—after much practice—becomes an "automatic" and pleasurable movement that creates beautiful sequences of sound.

- **Second nature:** After several months of applying principles of good composition in your drawings (as well as paintings, prints, sculptures, designs, and any other work for your art classes), you will "think" about these things much less and find that they seem to just *happen* when you make art.

- **Bliss:** Becoming adept at good composition is part of the "bliss" of being an artist. It's when other people exclaim about how "talented" you are and how "everything you touch" becomes beautiful. They will have no idea that you are following guidelines learned in your drawing class! You will make it seem effortless. After much practice, it will even seem effortless to YOU!

- **Subconscious of viewer:** Good drawings suggest a sense of order to viewers while at the same time capturing their interest and keeping them looking. Most people (those who are not artists themselves) sense these things unconsciously. Often, they don't understand why the drawing by one artist is so captivating and another drawing is just "ho-hum." Drawing students learning the principles of good composition know how this difference has been achieved.

- **Think of these principles as guidelines:** Because drawing and art are often considered to be magical, visionary, and impossible to quantify, many people resist the idea that there can be guidelines to follow. Although it is true that art needs freedom of expression to stay alive, there must also be a balance struck between the powers of free expression and

the need for unified wholeness. By thinking of these compositional principles as "guidelines" rather than rigid "rules," you can learn to use them while freely expressing your vision.

The Visual Elements

Physically, most drawings are composed of marks made by an artist using some tool or **medium** on the surface of a sheet of paper. However, for the eye and the mind behind it, a drawing is made up of its **visual elements.** When you look at a drawing, what you see are shapes and lines. Sometimes you see lights and darks. Sometimes a movement is implied by these elements. Sometimes you see textures. These are the visual elements of drawing.

The Principles of Good Composition

There are at least eight important principles of good composition that, when learned and applied to your drawings, can make them visually organized and unified:

1. **Unity.** Unity is the central principle of composition; all other principles of visual organization work together to create unity in a drawing. Unity creates a seamless sense of "wholeness" rather than a collection of parts. It is achieved by using the following compositional principles.

2. **Positive and negative shapes.** It is extremely important to learn that **every** shape in your drawing is an important part of the unity of your composition. Most people are aware of the positive shapes in their drawings, the shapes they "draw" based on the objects they see. What most people don't see are what we call the negative shapes. These are the shapes you must **learn to see.** These are the "holes," the shapes around and between the positive shapes. These shapes are just as important to your composition as the positive shapes. (See Chapters 1 and 4 for definitions and more information about positive and negative shapes.)

 Learning to see negative shapes: In your drawing class, your instructor will give you exercises and assignments to help you see and draw negative shapes.

 Practice: In your sketchbook, you can continue to practice by making many negative shape drawings.

 Pay attention: Once you have been taught to see negative shapes, you will notice them everywhere around you. What is amazing is that before this, you have only been paying attention to **half** of the visual world. Now you will see it **all!**

 Thumbnail sketches; beginning a new composition: In an effort to arrive at a strong composition, begin by experimenting with a variety of pictorial arrangements working with **thumbnail sketches.** Thumbnail sketches are small, quick sketches created with the sole purpose of arranging the simplified shapes, representing the objects you will be drawing, and evaluating how those shapes will relate to the outer edges of the picture plane.

 It is very important to begin your thumbnail sketches with a drawn border that matches the proportions of the final picture plane on which you will be working. For example, a sheet of 18X24" paper is a rectangle, not a square! The formatted thumbnail sketch pages provided in the appendix of this book match the proportions of an 18X24" sheet of

Medium: (plural, media) In works of art, the medium is the physical material used to make the artwork. In a painting, the medium might be an oil paint on canvas. A sculptural medium might be wood or metal. In drawing, the media are the tools and materials used to make marks on the paper and the paper itself. (Refer to the Introduction for a discussion of the various media you will be using in your drawing class.)

Visual elements: The visual elements in drawings are the various marks, shapes, lines, volumes, spaces, implied movements, textures, and values within the edges of the paper surface. You will be studying each of these elements individually and then learning how to combine them into compositions.

Thumbnail sketches: To save time and energy, artists work out their compositions with small sketches before they start work on the actual drawing paper. The term *thumbnail sketch* refers to these small sketches. Usually, not as small as your thumbnail, you can fit several of these sketches on a page of your sketchbook. (Several blank thumbnail-sketch sheets have been provided for your use in the appendix.) A thumbnail sketch can help you quickly "frame" your subject, try a variety of distances, try a

horizontal or vertical orientation, and make selections as to what to include and what to leave out of your composition. Thumbnail sketches are **not** drawings! They **are done very quickly.** They **don't include details,** just basic shapes, enough to determine the visual flow, balance, emphasis, and harmony of a composition.

Viewfinder: The term comes from pre-digital photography; film cameras have a viewfinder though which you can see what the camera lens has framed. A viewfinder can be anything that functions to block out and "frame" a particular segment of what you see. A card with a rectangular window cut out is traditionally what artists use as a viewfinder. It is very helpful to have the "window" conform to the same proportions (height and width) as your drawing paper. In the appendix of this book, we have provided a viewfinder (proportional to your drawing paper) for your use.

drawing paper. Traditional thumbnail sketches are small (3-5 inches), drawn very quickly using simplified shapes that represent the objects you will be drawing. When you become proficient with thumbnail sketches you could create 8-10 thumbnails in just a few minutes! Do not be overly concerned with accuracy or detail in your thumbnail sketches, work only with simplified shapes concentrating on the placement of those shapes in relationship to the outer edges of the picture plane. When evaluating the success of a thumbnail sketch, refer to the 'Compositions to Avoid' diagram on the following page in your textbook. The 'problem compositions' illustrated in this diagram can help to understand the arrangements of objects in a composition that are best to avoid. Instead, select thumbnail sketches with negative shapes that relate to (or echo) one another, or that relate to (or echo) some of the positive shapes in your drawing. Also look for negative and positive shapes that vary in size. There are infinite possibilities when developing compositions. You will soon begin to notice, within any given class, the countless different approaches students will take to the exact same subject matter. Arriving at your own solution to a compositional problem is one of the ways that your creative, individual eye begins to develop.

You can create a variety of options for your composition by drawing different parts of the still life, shifting your position in relation to the still life, zooming in or out on the objects, or rearranging the objects in the still life (rearranging the objects in the still life is only possible when working on your own still life at home). Using your viewfinder (provided in the appendix of this book) is very helpful in locating different options for your thumbnail sketches. When looking through the **viewfinder,** move it up, move it down, to the left, to the right, position it horizontally, or vertically, closer to your face, and further away from your face to arrive at the many possibilities for compositions. The viewfinder defines the boundaries of the proposed compositions, allowing you to visualize how the forms will fit in the picture plane and the positive and negative shapes that will be created as a result. The division lines located at the outer edges of the viewfinder will help to create landmarks, these can be very useful when transferring your thumbnail sketch onto the final drawing surface.

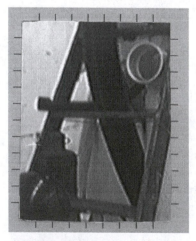

FIGURE 2–1
View of still life through the viewfinder
Photo Courtesy of Kyle Clohessy

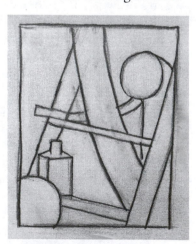

FIGURE 2–2
Resulting thumbnail sketch from view in Figure 2-1
Drawing and Photo Courtesy of Laurie Steinhorst

Compositions to Avoid

The following illustrations will help you remember things to avoid in your drawing compositions. Each of the "problem compositions" can make your drawing appear static, uninteresting, nonharmonious, or lacking in unity.

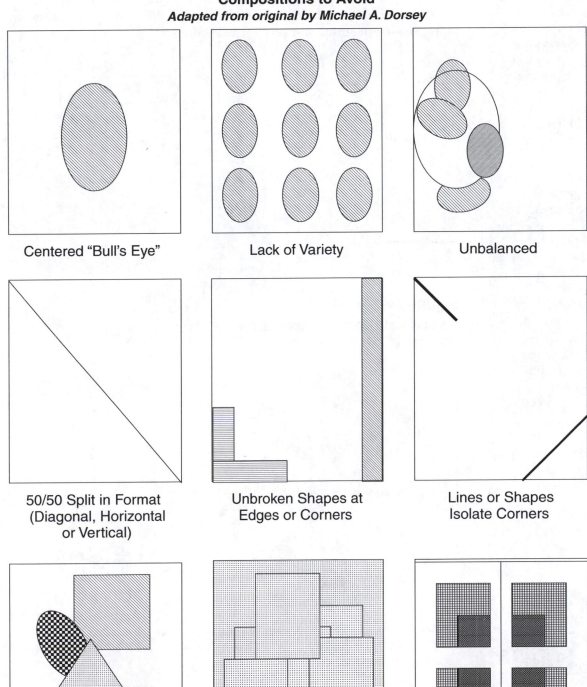

Compositions to Avoid
Adapted from original by Michael A. Dorsey

Centered "Bull's Eye"

Lack of Variety

Unbalanced

50/50 Split in Format (Diagonal, Horizontal or Vertical)

Unbroken Shapes at Edges or Corners

Lines or Shapes Isolate Corners

Lack of Repetition

Lack of Contrast

Symmetrical Composition

Adapted from original by Michael A. Dorsey

Balance: is often defined as a state of equilibrium, as when two things of equal weight "balance" on a scale. In drawings, when we refer to balance, we are talking about *visual* equilibrium. One side of a drawing should not dominate the viewer's perception; the two sides of a drawing are visually balanced when they each have an equal pull on the eye and the brain of an observer.

Symmetrical balance/symmetry: The mirror-repetition on two sides of an imaginary center line (usually vertical, but sometimes horizontal). Symmetrical balance is best understood by referring to a frontal view of the standing human figure. On either side of an imaginary vertical line is a mirror version of an eye, a nostril, a shoulder, an arm, a leg, etc. Symmetry is a visually powerful system of organization. For the artist, it is often *too* powerful and *too* predictable. Once one side of an image has been established, the other side is just a reverse echo.

Radial Balance: This form of symmetry is created when elements "radiate" in all directions (360 degrees) from a central point. Although found in nature (many flowers are an obvious example), radial symmetry is the most static form of balance.

3. **Balance.** Visual **balance** is essential to creating unity in your drawing compositions. There are three basic types of balance: **symmetrical balance**, **radial balance**, and **asymmetrical balance**. Many artists prefer to achieve balance with asymmetrical balance, also called *asymmetry*. In your drawing class you will be encouraged to master asymmetrical balance in your work. Symmetrical balance, also called *symmetry*, and radial balance, also called *radial-symmetry*, are sometimes useful to the artist, but only when the concept requires an expression of stasis, or a very formal order.

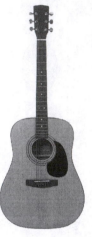

FIGURE 2–3
Symmetrical Balance: Acoustic Guitar
RemarkEliza/Shutterstock.com

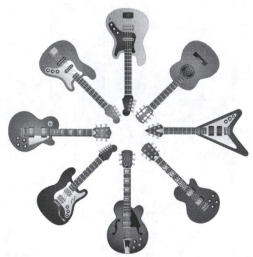

FIGURE 2–4
Radial Balance: 8 Guitars
resnak/Shutterstock.com

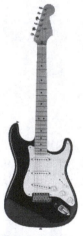

FIGURE 2–5
Asymmetrical Balance:
Electric Guitar
Idutko/Shutterstock.com

4. **Visual flow and directional forces.** In addition to conveying a sense of unity, a good composition (and therefore a good drawing) is often designed to lead a viewer's eye around and through the drawing. This movement is called **visual flow**. Visual flow can be established in many

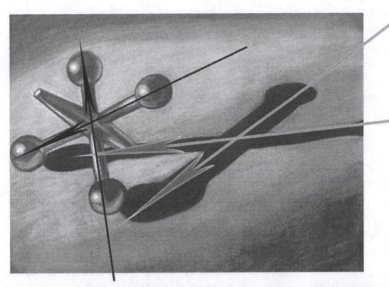

THIS DRAWING FROM CHAPTER 6 ILLUSTRATES HOW LINEAR
ELEMENTS IN A COMPOSITION CAN CREATE VISUAL FLOW, LEAD
THE VIEWER'S EYE THROUGH A COMPOSITION, AND PRODUCE
HARMONY THRUOGH REPETITION WITH VARIATION.
(THE ARROWS INDICATE LINES AS DIRECTIONAL FORCES.)

FIGURE 2–6
Linear Elements Creating Visual Flow.
Drawing by Gayle Malheiro, Photo Courtesy of Laurie Steinhorst

Asymmetrical Balance:
Asymmetrical balance, also called *asymmetry*, is the balance most artists use in drawings, paintings, photographs, and prints. Asymmetry *is* balance, but without identical elements on either side of an axis. Instead, asymmetry is created by balancing different, but visually equal, elements on each side. For example, a large simple object on one side of a composition might be balanced by a smaller, very detailed object on the other side. Achieving asymmetrical balance is more challenging for the artist, just as perceiving asymmetrical balance is more engaging for the viewer. That is why artists prefer to use asymmetry: They love being challenged, and they are not often fond of making art that bores their viewers.

Visual flow and directional forces: **Implied** movements within and through a composition. This flow is created in several ways using the visual elements to "move the eye" of a viewer over the drawing format.

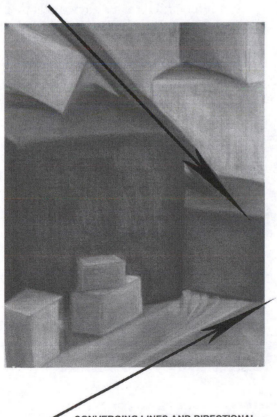

CONVERGING LINES AND DIRECTIONAL
FORCES CREATE VISUAL FLOW

(THIS DRAWING IS FIGURE 6-8 IN CHAPTER 6)

FIGURE 2–7
Converging Lines
Drawing by Marina Malinas, Photo Courtesy of Carla Rae Johnson

Value: Value is the term we use when we discuss the lights and darks in a drawing or any work of art. (For more detailed information on value, see Chapter 6.)

Emphasis: An artist's way of stressing or making bold a portion of a drawing or artwork. Creating emphasis is to make something "stand out" from the other things around it.

Focal point: A focal point is the location in a composition that attracts the viewer's attention and may continue to draw attention back to itself again and again. Some compositions have primary and secondary focal points. A primary focal point is the dominant feature in the composition. While secondary focal points have some visual pull, they are somewhat subordinate to the primary focal point. Focal points help to create a sense of order in your compositions.

Harmony: To be in harmony is to be in agreement. Harmony in compositions is created by combinations of elements that "agree" with each other, maintaining just the right mix of similarities and differences to keep them interesting and pleasing to the eye.

ways. Here are a few ways the visual elements in a drawing can create **directional forces** or visual flow:

a. **Line:** Major linear elements of a composition often encourage the viewer's eye to move through a drawing. Our eyes tend to move along to follow the curve or angle of a line from one end to the other.

b. **Lines that converge:** Lines or edges that converge to a point pull the eye in that direction. You can use this method to draw a viewer's attention in a desired direction in your drawing.

c. **Sequence of repeated shapes:** An artist uses repeating shapes of varied sizes to lead the eye from one to the next, moving around the composition. (See Figure 2-7.)

d. **Sequence of values:** By repeating a light, dark, or even a mid-range **value** in a drawing, you can encourage the viewer to follow these repetitions. (See Figure 2-9.)

e. **Space:** Drawings often intentionally create an illusion of space or depth. A viewer will be "drawn into" your drawing's space through this kind of illusion; thus, the visual flow moves into the deeper spaces of a drawing. (See Figure 2-6.)

5. **Emphasis.** One of the most effective ways to unify a composition is to create an area of **emphasis**. This is often called a **focal point**. Emphasis in a particular area will keep the viewer's eye coming back to focus on this point of the composition. At times, a drawing composition might have a dominant and one or more subordinate focal points. This kind of composition can keep the viewer's attention moving among the points of interest. Here are a few ways that the visual elements can be arranged in a drawing to create areas of emphasis, or focal points:

6. **Harmony.** The human mind is attracted to anything harmonious. In music, a chord or series of notes that resonate together can create **harmony**. Artists also use harmony to visually unify compositions. In

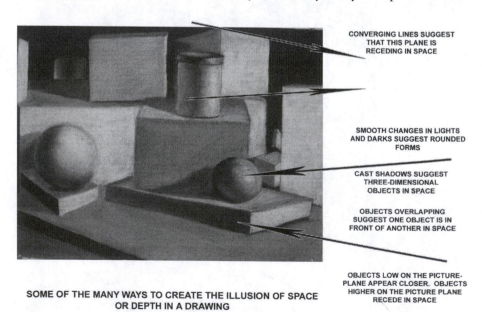

CONVERGING LINES SUGGEST THAT THIS PLANE IS RECEDING IN SPACE

SMOOTH CHANGES IN LIGHTS AND DARKS SUGGEST ROUNDED FORMS

CAST SHADOWS SUGGEST THREE-DIMENSIONAL OBJECTS IN SPACE

OBJECTS OVERLAPPING SUGGEST ONE OBJECT IS IN FRONT OF ANOTHER IN SPACE

OBJECTS LOW ON THE PICTURE-PLANE APPEAR CLOSER. OBJECTS HIGHER ON THE PICTURE PLANE RECEDE IN SPACE

SOME OF THE MANY WAYS TO CREATE THE ILLUSION OF SPACE OR DEPTH IN A DRAWING

(THIS DRAWING IS FIGURE 6-12 IN CHAPTER 6)

FIGURE 2–8
Annotated Drawing Indicating Spatial Illusions
Drawing by Keith Greenbaum, Photo Courtesy of Carla Rae Johnson

SOME WAYS TO CREATE A FOCAL POINT

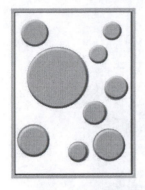

LARGE AMONG SMALL

SMALL AMONG LARGE

DARK AMONG LIGHT

LIGHT AMONG DARK

LOCATION: NEAR CENTER

DIRECTIONAL FORCES

DETAIL = INTEREST

RECOGNITION = INTEREST

CURVE AMONG STRAIGHT

TENSION AT EDGE

PROXIMITY = TENSION

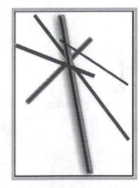

CONVERGING LINES

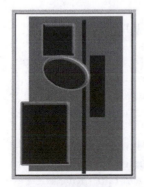

ORGANIC AMONG GEOMETRIC

IRREGULAR AMONG REGULAR

DIRECTIONAL CONTRAST

TEXTURE CONTRAST

Courtesy of Carla Rae Johnson

FIGURE 2–9
Repeated Shapes
Drawing by Lauren Helms,
Photo Courtesy of Carla
Rae Johnson

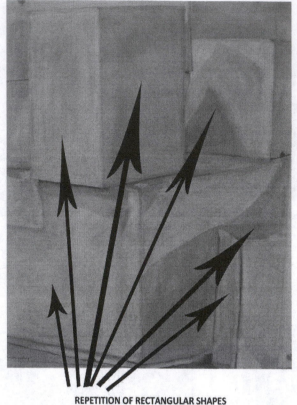

**REPETITION OF RECTANGULAR SHAPES
OF VARIED SIZES**

(THIS DRAWING IS FIGURE 6-9 IN CHAPTER 6)

Repetition and variation: One of the most effective ways to evoke harmony is to repeat elements. To keep things interesting, artists repeat these elements with some variations. Variations can include contrasts in proportions, shapes, values, textures, and other qualities.

drawings, harmony is created by "repetition" of visual elements. Too much repetition, however, can become monotonous, so artists must take care to vary some qualities of repeated elements. Here are some hints that might help you use **repetition and variation** effectively in your drawing compositions:

a. **Repetition of shapes:** When selecting an area of a subject for your drawing composition (use your viewfinder), look for repeated shapes or shapes that "echo" each other. These shapes can be found in either the positive or the negative spaces of the subject. Try to find shapes that vary in size, value, texture, or proportion to prevent too much repetition.

b. **Repetition of line:** Lines can echo each other, too. Parallel lines do this, as do lines that pause and start again (the viewer's eye will "close the gap" and find this continuation to be a pleasurable experience). The reversal of a curve in an S-shaped linear movement is also a pleasing repetition. By varying the quality of lines in your drawings, you can avoid becoming too repetitious. (See the discussion on line quality in Chapter 3.)

c. **Repetition of values:** It is quite natural that some values in a shaded drawing will repeat. The use of a black, for example, in larger and smaller shapes within a composition can move the eye and provide harmony.

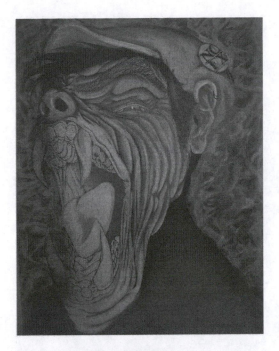

REPEATED LINES IN THE FACE, MOUTH, HAIR, AND IN THE
NEGATIVE SPACES OF THIS DRAWING HELP TO LEAD THE
VIEWER'S EYE AND CREATE HARMONY THROUGH REPETITION
WITH VARIATIONS.

(DRAWING BY ADRIAN FRANCO)

FIGURE 2–10
Repeated Lines
Drawing by Adrian Franco,
Photo Courtesy of Carla
Rae Johnson

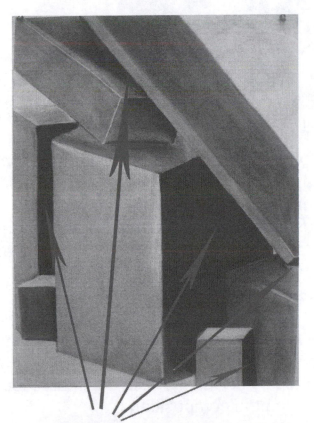

REPEATED VALUES CREATE HARMONY AND MOVE THE
VIEWER'S EYE THROUGH A COMPOSITION

(THIS DRAWING IS FIGURE 6-10 IN CHAPTER 6)

FIGURE 2–11
Repeated Values
Drawing by Kaylene
Morgan

THE RULE OF THIRDS

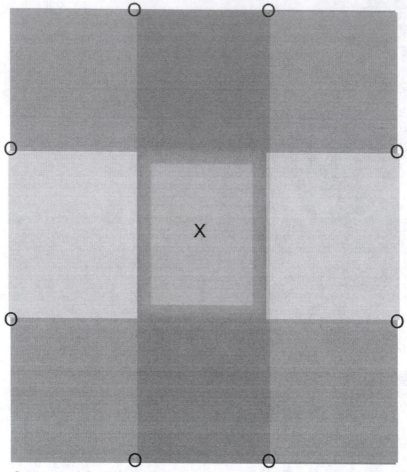

Courtesy of Carla Rae Johnson

Imagine your drawing paper divided into three equal sections both vertically and horizontally.

As you create your composition, the best choices for placing a strong vertical are at the edges of the darker column in the diagram above. The best choices for placing a strong horizontal are at the edges of the light bar across the middle.

Among the best choices for placing a focal point are at the edges of the central rectangle. (The "X" in the center of the diagram above, indicates that this is NOT where to place a focal point: this would create a "bulls-eye" composition.)

Any of the points indicated by an "O" indicate desireable locations for anything entering or leaving the composition.

7. **The "golden section".** There is a proportional relationship that has been universally accepted as elegant and ideal. In Ancient Greece, artists, artisans, and architects began to adhere to a proportional "ideal" called the "golden section" or the "golden mean." This was a specific ratio, often of height to width, based on a mathematical relationship, but also a proportion that appears consistently in nature: in the human body, a sunflower, and the chambered nautilus. To this day artists and designers adhere to this ideal proportion in their work. For our purposes in a beginning drawing course, we are simplifying this proportional ideal, by describing it as "the rule of thirds." To use the golden section in your drawings, simply use a one-third to two-thirds ratio for placement, size, linear, and/or volume relationships.

8. **Simplicity/economy.** We have saved one of the most important compositional principles for the end. Simplicity, also called economy, is both a principle of good composition and a way of life. In our culture and our society there is constant pressure to do more, see more, earn more, buy more, and have more, but **in making art**, it becomes important to proceed with a counterpoint to these tendencies. A famous modern architect, Ludwig Mies van der Rohe, provided the dictum that sums up this important principle: "Less is more." When you use your viewfinder to select an area from the subject or still life, your natural tendency is to include many objects. When trying to complete a composition or to resolve a compositional problem, your first impulse will almost always be to add something else. Your drawing instructor and your classmates will remind you at the easel, and often during a critique, that the better course of action for a strong composition is to follow the dictum "Less is more."

Here are some bits of advice:

Be selective: Move your viewfinder further from your eye to "zoom-in" on an area that includes **just enough** to make your composition interesting and dynamic, and **no more.**

Practice economy: The phrase "economy of means" suggests doing more with less.

- Rather than filling in an entire area of texture, leave some parts for the viewer's imagination to complete.
- Rather than completing a contour, leave an opening; the viewer's brain will delight in providing "closure."
- Rather than putting in **every** detail, be selective about where and when to provide details. You get the idea?

"K.I.S.S." The most succinct expression of simplicity and economy of means came to us from the U.S. Marine Corps. The Marines have a saying: "Keep It Simple Stupid" ("K.I.S.S."). In class, we prefer to say "keep it simple, sweetheart" so that no one can take offense. Whenever you are tempted to **add** something or to resolve a composition with **more stuff,** say "K.I.S.S." to yourself and find a way to complete your work with **less** rather than more.

Simplicity/economy: For our purposes in discussing drawings and compositions, we may use the terms *simplicity* and *economy* interchangeably. They both refer to the practice of doing the most with the least. Simplicity is not the same as "simple" or "simplistic"; it is a sophisticated state of being and way of visually thinking that does not allow anything to be added unless absolutely necessary to the composition. In short, if your composition has achieved simplicity, you will not be able to remove **anything** without upsetting the delicate balance of elements.

9. **Critique your own drawings.** Here is a list of questions you can ask yourself as you are working on a drawing:

Some Compositional Questions to Address When You Look at Your Drawings

- **"Less is more"**/K.I.S.S.:–Is everything included *necessary* to the composition?
- **Negative spaces:**–Interesting? Considered? Related to positive spaces?
- **Focal point:**–Is there a primary focal point? Is there a secondary focal point? Do either of these need more/less emphasis?
- **Visual flow:**–How are the directional forces leading the eye in this drawing?
- **Harmony:**–Are there repetitions of shape, line character, values, spaces, etc. in this composition? Are there variations in these repetitions?
- **Balance:**–Is this composition balanced? Is it balanced asymmetrically?
- **Golden section:**–Is the rule of thirds used in this composition?
- **Energy:**–Does this composition create a feeling of energy? If not, what does it express?

Summary

Synergy: State in which the whole is greater than the sum of its parts. That's what we strive for in the best drawing compositions!

Our aim in this chapter is to provide you with some guidelines to follow in your drawings. During your critique sessions, you will see the many ways that a single subject can be seen and its various elements ordered into a unified whole. The more drawing compositions you **create** and the more drawing compositions you **look at** during critiques, the more clarity you will develop toward understanding the **synergy** of a good composition.

Chapter 3
Contour Line

Contour line drawing is a great way to learn to **see**. Seeing accurately is the **most important skill** for anyone who draws. Not just "beginning exercises," the practice of blind and semi-blind contour line drawing helps you to understand the vital connection between eye and hand and how they can learn to move together, with the eye informing the hand and the hand recreating what the eye has seen. These techniques also help you to avoid a most troublesome habit that interferes with good drawing skill. That most troublesome habit is mentioned in the introduction to this book: it is drawing **what you think you see** rather than what is actually **there** in front of you. Even though you will only be required to do a few drawings with this technique, you are advised to continue to practice contour line drawing as much and as often as you can. Like practicing musical scales or a tennis swing, this technique will reinforce that important connection that exists when the movement of your eye is in concert with the movement of your hand.

Why Contour Line Drawing?

The practice of contour line drawing will allow you to build important skills that you will use throughout this course.

- **Eye/hand coordination** – Following contours with your eye and hand improves what we call eye/hand coordination. This ability is essential to drawing skillfully, quickly, and accurately.

- **Observational skills** – Practice with contour line drawing greatly improves observational skills. More than any other drawing technique, practice in carefully and accurately following contours and cross-contours improves your attention to detail, shapes, volumes, surfaces, and edges. Since the single most important skill needed for success in drawing well is **seeing** well, this way of drawing starts you off on the right track.

- **Confidence** – Practice in contour line drawing improves confidence in your ability to draw, learning to trust your eye.

- **Encouragement for the real beginner** – Those who have little experience drawing sometimes succeed even more quickly at accurate contour line drawing because they have not developed habits of drawing what they "**think**" is there. For those who have developed drawing habits that are focused on "thinking" rather than "seeing," contour line drawing is the best antidote!

- **Accuracy** – Carefully executed contour line drawings can attain close to photographic accuracy.

Contour line drawing: Contour refers to the edges of a shape or lines that follow the surface "skin" of an object. Objects have "exterior" edges/contours, often called *outlines*, and "interior" contours, called *cross-contours*. Contour line drawing is a drawing method in which the eye and hand move together following the edges (contours) of forms and objects. Contour line drawing is always done without looking at the drawing paper as you draw.

Eye/hand coordination: When your eye and your hand move in sync as they follow an edge to create a line that precisely relates to that edge, you are practicing eye/hand coordination. You might substitute the word *cooperation* [eye/hand cooperation] to help understand this concept. Eye and hand work together *cooperatively* to follow the contours you see. Another way to help you understand this concept is to think of how the cursor on your computer screen moves in sync with the mouse on a mouse pad. If your eye is

following the cursor, your eye and your hand are coordinated in their movements when you move the mouse with your hand.

Cross-contours: These contour lines follow the "interior" edges of a form or object rather than the "exterior" edges/outlines. It is easy to discern the cross-contours on a striped t-shirt or the lines that are formed on the sections of a pumpkin, but cross-contours can be drawn even when you cannot *see* them. With practice, you will learn to sense and draw cross-contours on objects even if there are no lines you can see on the object's surface. To help you envision these cross-contours, think of the equator and longitude and latitude lines on a globe. These lines don't exist on the earth itself, but they are the cross-contours of the earth. Cross-contour lines enhance the illusion of three-dimensional form in any line drawing.

- **Lesson that drawing is process** – A famous artist, Richard Serra, stated, "Drawing is a verb" (Serra 1976). Thinking of drawing as a **process**, rather than a **product,** is one of the benefits of contour line drawing. It's about the process of moving your eye over contours and moving your hand in that same sequence of motions over your paper. It begins to feel as if you are seeing not just with your eye, but also with your hand.

- **Discipline** – The self-discipline you gain by drawing in this way becomes your introduction to the "discipline" of drawing. The focus needed for creating a really good drawing is what you will begin to master when you master this drawing technique.

- **Attention to line** – Most artists who draw identify line as the single, most definitive visual element associated with drawing. Blind and semi-blind contour line drawings are created exclusively with lines. There is a certain elegance, simplicity, and directness in this approach.

- **Line shading** – As you practice this technique and become increasingly confident and efficient in following contours and **cross-contours,** you can begin to darken portions of the objects in your drawing that you notice are in shadow. Shading can be achieved in contour line drawings by following many, many cross-contours (lines close to each other). The more cross-contour lines drawn in an area, the darker that area appears in the drawing.

FIGURE 3–1

Example of Contour Line Shading
Drawing by Carla Rae Johnson

Technique: Blind Contour Line Drawing

- **Draw it "blind."** Draw the subject **without looking at the drawing paper. You must look ONLY at the subject you are drawing.** You must resist the temptation to "peek." Quite seriously, **if you look once, you will not be able to continue without looking again and again!**

- **Use a continuous line: Do not take your pencil off the paper.** This is necessary to help you keep your place when you cannot "see" where you are on the paper. Note: If you feel your pen or pencil go off the edge, without looking, move your hand back to where you left the paper edge and continue drawing.

- **Proceed slowly and carefully.** Concentrate, focus, and draw the object as if you are tracing its contours.

- **Keep it flowing.** Keep the line "fluid" but **do not scribble.** Proceed with a slow and studied pace much like tracing.

- **Follow contours and cross-contours.** Follow both outside and inside contours, or cross-contours. These contours follow the form much as a string would do if it were wrapped around the object you are drawing.

- **Fill the page.** Your drawing should touch all four edges of your drawing paper.

- **Don't judge.** Do not judge this drawing by the standards you usually use to assess your drawings. This is an important exercise in "seeing." You will be drawing the object(s) as you **see** them, not as you **think** you know them!

- **Stick to the guidelines.** If you carefully follow the guidelines presented in this chapter, (believe it or not) this will be the best drawing you have ever done!

- **Product is the result of process.** Contour line drawing is more about "process" than "product." Stay focused on this **process** of drawing and you will learn a great deal very quickly. The **real** "product" will be what you eye, and your hand, and your brain **learn** as you draw this way, rather than what your drawing looks like. (Figures 3-2, 3-3, 3-4, and 3-5 are examples of students' blind-contour line drawings.)

FIGURE 3–2
Blind Contour Line
Drawing by Diamonte Chestnut,
Photo Courtesy of Kyle Clohessy

FIGURE 3–3
Blind Contour Line
Drawing by Rebecca Rodriguez, Photo
Courtesy of Laurie Steinhorst

FIGURE 3–4
Blind Contour Line
Drawn by Justin Wong,
Photo Courtesy of Laurie
Steinhorst

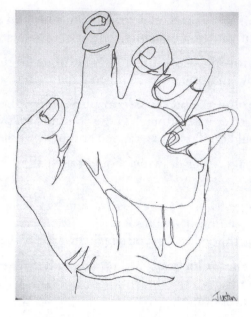

FIGURE 3–5
Blind Contour Line
Drawn by Bradleigh Miller,
Photo Courtesy of Laurie
Steinhorst

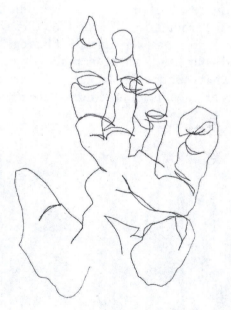

Technique: Semi-Blind Contour Line Drawing

- **Don't look!** The same guidelines practiced in **blind contour line** drawing are to be carefully followed for semi-blind contour line drawing with the following exception: You may **look** at your drawing, but you may not "**draw**" while you "**look**."

- **Stop!** Your pen/pencil **must stop** when you look down! You can begin moving your pencil again when your eyes go back to the subject.

- **Practice.** With a little practice (which involves learned behavior and coordination), you will be looking rapidly back and forth from the subject to the drawing, stopping and starting your pen/pencil appropriately to create a semi-blind contour line. Lots of practice makes this technique become second nature.

- **Focus and concentrate.** Proceed carefully and slowly. Concentrate, focus, and draw the object as if you were "tracing" its contours. Use your best observational skills. Imagine your pen/pencil is a tiny ant crawling over the contours of the subjects.

- **Keep it flowing.** Keep your line "fluid" but DO NOT SCRIBBLE. A slow and studied pace works best. As you become more practiced and you can coordinate stopping to observe with looking and drawing, the pace will pick up a bit.

- **Follow contours and cross-contours.** Follow both outside and inside contours. Cross-contour lines will help you to define the forms and create a sense of volume in the objects drawn.

- **Let it breathe.** Avoid completing every outline. Allow the forms to "breathe" by leaving openings in your outer contours. Some forms can be completely defined by their cross-contours without any outline at all.

- **Fill the page.** Your drawing should touch all four edges of your paper.

- **Suggest shading.** Using only lines (cross-contours), you can create the look of shading in your contour line drawings. Use lots of cross-contours in the darkest areas you see. The white paper will become the lights and highlights (see Figure 3-1).

- **Look for amazing results.** Semi-blind contour line drawings can be amazingly detailed and are often highly realistic in appearance. You will be amazed at how well you can draw! (Figures 3-8, 3-9, and 3-10 are examples of students' semi-blind contour line drawings.)

Sequence for Semi-Blind Contour Line Drawing

- **Thumbnail sketches:** Using a **viewfinder** (provided in the appendix of this book), select interesting areas of the subject matter and do preliminary **thumbnail sketches** (quickly) to select and refine your composition. Do thumbnail sketches on "thumbnail" pages (provided in the appendix of this book). Note: If you create your own thumbnails, be sure to trace the window opening of your viewfinder to make the thumbnail outlines. This will ensure that your thumbnail sketches will always be the same format as your drawing paper so that the proportions of your sketch remain accurate when you enlarge your sketch onto your drawing paper.

- **Block in:** After selecting your best composition in a thumbnail sketch, you will use a graphite pencil to lightly begin **blocking in only the main shapes** of your composition on your full-size drawing paper. Do not draw details—only the basic shapes. Refer to the composition in your thumbnail sketch, but **look at the subject** as you block in what you see. (See Figure 3-6.)

- **Start the line:** Use a soft graphite, ebony pencil, or fine felt-tip marker to begin your semi-blind contour line using the techniques discussed previously. Your lightly blocked-in shapes will act as a guide to keep your proportions fairly accurate.

Blocking in: To block in is to lightly indicate where the basic shapes are in your composition. Blocking in is a preliminary sketching process done very lightly with an erasable medium (such as a pencil). During the blocking-in process, the composition is refined from the original thumbnail sketch, and the visual flow, balance, and other compositional concerns are determined. Blocking in is a **simple** indication of the basic shapes and volumes you see **without any details, contours, or shading.** As you block in, you can make changes or corrections to make the sizes and shapes of things more accurate. This preliminary step will become your guide when you begin to follow contours in your semi-blind contour line drawing.

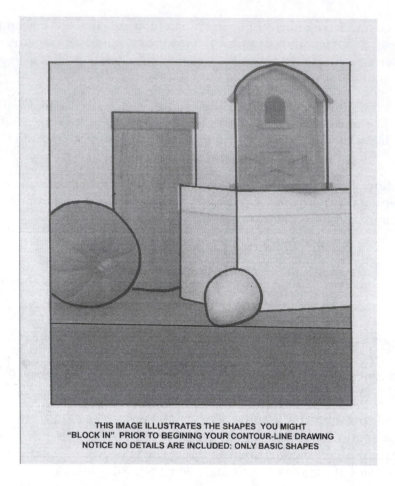

THIS IMAGE ILLUSTRATES THE SHAPES YOU MIGHT
"BLOCK IN" PRIOR TO BEGINING YOUR CONTOUR-LINE DRAWING
NOTICE NO DETAILS ARE INCLUDED: ONLY BASIC SHAPES

Line Quality

One earmark of any great drawing is the ways in which an artist has created variation in the quality of lines. Because line is the most basic and fundamental element in a drawing, it is important that students use line to its full potential. You can enrich your contour line drawings by creating variations in the quality of the lines. You can achieve these effects in

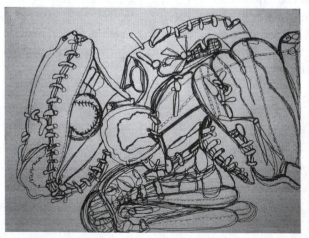

FIGURE 3–7
Line variation in semi-blind contour line drawing by Sari Zubatkin

several ways: list reasons for line variations i.e. sense of variety, create directional pull, give sense of weight, depth of space, help to create texture. (Figure 3-7 illustrates varied line quality in a semi-blind contour line drawing.)

Variation in line quality

- Vary the pressure on your pencil for lighter/thinner or darker/thicker lines.

- Use your pen or felt-tip marker to create thicker/thinner lines by following a contour once or going over that same contour many times to increase the thickness. Explore the ways you can vary line thickness with these drawing tools.

- Keep in mind that lines can feel quick, slow, studied, broken, straight, curved, irregular, static, energetic, or self-conscious. Each of these qualities can affect character or expression in a drawing. Experiment with many types of line and become sensitive to their expressive potential.

- Use lines of varied weight (thickness and value) in your drawings.

- Use lines to create a sense of space and depth. Discover ways that linear elements can create an illusion of depth.

- Darker lines move forward & feel heavier, lighter lines recede into space & feel lighter.

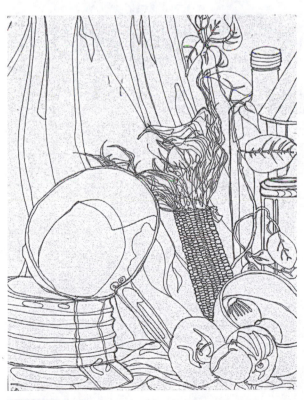

FIGURE 3–8
Semi-blind Countour Line Drawing by Olhi Gomez
Photo Courtesy of Carla Rae Johnson

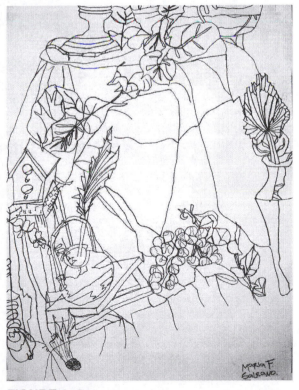

FIGURE 3–9
Semi-blind Countour Line Drawing by Maria Fernanda Galeano
Photo Courtesy of Carla Rae Johnson

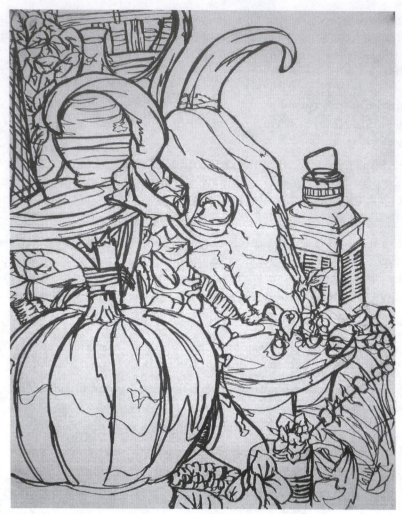

FIGURE 3–10
Semi-blind Countour Line Drawing by Justin Wong
Photo Courtesy of Laurie Steinhorst

Works Cited

Serra, Richard. Keynote address at the Museum of Modern Art, New York, for "Drawing Now,"1976.

Chapter 4
Positive Space/ Negative Space

Shapes, Forms, and Space

Drawing is a **two-dimensional** art form. When drawing from **direct observation,** you are looking at a **three-dimensional** *form* (a form has height, width, and depth) and translating it into a two-dimensional *shape* (a shape has height and width but no depth) and then drawing that shape onto a two-dimensional piece of paper. Therefore, drawings are made up of shapes on a two-dimensional surface. Some shapes in a drawing might have the illusion of volume and form, but they are still shapes. They have no physical depth.

There are two different types of shapes in drawing. **Positive shapes** refer to the objects you draw; **negative shapes** refer to the space between objects or the empty space in a drawing. When designing a composition, we tend to focus our attention on the objects we are drawing, the positive shapes. This is natural as the positive shapes are usually the focal point of the drawing. In addition, positive shapes tend to have more defined edges than negative shapes, making them easier to see. However, the negative shapes are equally important as the positive shapes in any successful composition.

The moment we draw a positive shape on our picture plane, we have automatically created negative shape or space, the "leftover" or background space. Positive and negative space are interrelated; they create

Two-dimensional:
A flat surface or shape that consists of only height and width, *no* depth.

Direct observation:
Drawing directly from objects you see, *not* drawing from the imagination or copying from photographs.

Three-dimensional:
A form that consists of height, width, and depth.

FIGURE 4–1
Object as three dimensional form
Photo Courtesy of Carla Rae Johnson

FIGURE 4–2
Object as two dimensional shape
Photo Courtesy of Carla Rae Johnson

FIGURE 4–3
Black shape represents
positive shape
Photo Courtesy of Carla
Rae Johnson

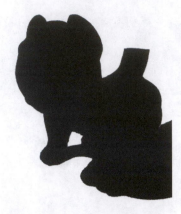

FIGURE 4–4
Black shape represents
negative shape
Photo Courtesy of Carla
Rae Johnson

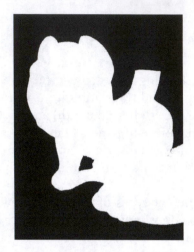

each other. Although the background of the drawing may seem unimportant, it is anything but. In a dynamic composition the entire picture plane and all the shapes in it must be drawn, considered, and realized in order to create dynamic energy and tension on the surface. A lack of attention to either the positive or negative shapes will flaw a composition. Both the positive and negative shapes must work together to create an energized relationship to the outer edges of the picture plane.

Because our natural inclination is to focus on the positive shapes, we must learn to see, focus on, and draw the negative shapes. This can be a challenging experience for beginning students who are not used to seeing those "empty" spaces.

Why Negative Shapes Are Important

Understanding the importance of negative shapes and considering them in your drawing compositions will improve your drawings significantly. Here are some advantages to considering negative shapes:

- **It engages the entire surface of the drawing.** Giving negative shapes equal attention will automatically give a sense of charged energy to those areas of the picture plane, making them more than just "leftover space."

- **It helps to find drawing mistakes.** Seeing the negative shapes helps to locate drawing mistakes. If you see a negative space in the still life but it doesn't exist in your drawing, that's a cue that a correction is needed.

FIGURE 4–5
Negative space drawing by Emily Engler
Photo Courtesy of Laurie Steinhorst

FIGURE 4–6
Negative space drawing by Faviola Tovar
Photo Courtesy of Carla Rae Johnson

- **It helps to correct drawing mistakes.** Negative shapes contain a lot of information about the relationships of the shapes in your drawing. If you are having trouble with a certain part of your drawing, refocusing on and drawing the negative shapes can help resolve those issues.

- **It creates a strong composition.** Having charged negative shapes/spaces creates a dynamic, energized composition.

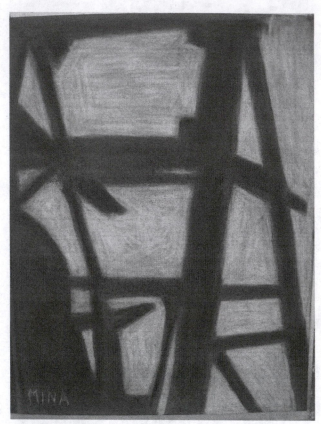

FIGURE 4–7
Negative space drawing by Marina Melinas Leva
Photo Courtesy of Carla Rae Johnson

Chapter 5

Sighting

Sighting is a technique that can train your eye, your brain, and your hand to work together smoothly to record what is in front of you with accurate angles (visual **perspective**) and **proportions** (relative sizes). Learning the sighting techniques discussed in this chapter and practiced in your drawing class and homework will be one of the most important aspects of your drawing experience. Initially this learning process may be frustrating to some students of drawing because they must **unlearn** some assumptions they have always had about how things appear in the world and some of the "how-to-draw" techniques they have used in the past. However, lots of practice and the self-discipline to follow each of the techniques as directed will result in drawings that will impress you and your audience in equal measure. Be patient with yourself. When you learn anything new (in particular, when that new learning requires the "unlearning" of former habits) the process may seem awkward, difficult, and "not natural." However, if you continue to adjust your hand and eye to the new techniques without "judging" yourself or your results (avoid statements like *"I can't do this!" "I'm just not good at this!" "This doesn't look like a drawing should look!"*), you will eventually see great improvements in your drawing skills. With practice you will begin to internalize this "way of seeing," and the whole process will become less mechanical.

Why Sighting?

Learning to observe the forms and spaces in the world around us is a valuable and useful skill. Sighting is one of the most effective ways to learn how to observe and record these forms and spaces with accuracy. Once you have mastered the skill of observing and recording accurately, you can begin to develop your own, very personal way of rendering that will become your "style."

- **Accurate angles:** Have you ever looked at a drawing you have completed and felt that something was "wrong" about the space or the edge of a table? Chances are that the perspective in your drawing is inaccurate. The sighting techniques you are about to learn will help you avoid this problem.

- **Linear perspective:** Some drawing courses and textbooks teach a system called **linear perspective**. You may want to explore this system on your own to learn how to use vanishing points, horizon lines, and one, two-, and three-point perspectives. For the purposes of this text and this introductory course in drawing, we feel you can accomplish accurate

Sighting: A particular set of techniques and skills that use your eye, arm, hand, and drawing tool to accurately transfer the angles, lengths, and widths from the subject to your drawing.

Perspective: The art of drawing on a flat surface in such a way as to create the illusion of three-dimensional forms in space on a two-dimensional plane (your drawing paper); accurate perspective in your drawing maintains the same relative distances, angles, and sizes as the subject when seen from a **fixed point of view**.

Proportions: Size relationships of one thing to another; accurate proportions in a drawing indicate that the relationships of one thing to another in the drawing are the same as those in the subject. (The distance and point of view must remain the same. The proportions you see will often change if you move, even slightly, to another spot.)

Linear perspective:
This system, originating in the Renaissance period of Western art, provided guidelines and rules for how to render objects and create the illusion of three-dimensional forms and space. The system and its vocabulary are complex and can often be confusing to students.

perspective in your drawings by following the visual sighting techniques we lay out for you here.

- **Accurate proportions:** Often, when you feel uncomfortable about something in your drawing, you are sensing inaccuracy in the proportions. Have you ever stood back from a drawing on which you were working and felt that the size relationships of objects or parts of a figure are not quite right? The sighting and measuring techniques you are about to learn will help you to improve the accuracy of size relationships in your drawings.

- **Accurate spaces:** In your study of positive spaces and negative spaces you learned how important space can be in drawings and other works of art. Your new understanding of negative space and your ability to focus on negative shapes can improve the accuracy in recording not only the negative, but also the positive spaces/shapes. Sighting techniques you are now learning can be applied to the observation and recording of negative spaces in your drawings to improve their accuracy and enhance the sense of three-dimensional forms in space.

- **Illusion:** The illusion of three-dimensional space on a two-dimensional plane (your drawing) is one of the most magical sensations a drawing can create. Mastering the skill of sighting can enhance the illusion of space and forms to make your drawings, not just convincing, but fascinating to your viewers.

Sighting Techniques

The importance of a fixed point of view – Since the Renaissance, artists have studied their subjects from a **fixed point of view.** (Many artists in the twentieth and twenty-first centuries have intentionally broken with this convention, but most of them learned the technique first in order to effectively "break the rules." You would be wise to follow their example! To "build a better mousetrap," the inventor needs to understand the dynamics of the existing models.) The fixed point of view is essential to the creation of works of art that create a "window-to-the-world" illusion of space and forms. Have you ever noticed, when you draw, that if you move your head, even a few inches to the side, the objects shift in perspective? This approach to drawing requires that the artist's eye be positioned in precisely the same place at all times. Much like a camera, you are recording the objects before you on your drawing paper without changing (even in the slightest) your point of view.

Fixed point of view:
A fixed point of view is essential to successfully creating an accurate illusion of depth and volume in your drawing. You need to stand in one place, but even more than that, your head and your eye (**one eye!** Keep one eye closed.) must return to the exact, same place each time you observe and draw a portion of your subject.

Establishing and maintaining a fixed point of view – Follow these instructions to establish and maintain a fixed point of view.

- Locate yourself just at arm's length from the drawing paper, so that your fingers can touch the paper. Your arm should be fully extended in this position, with your elbow locked. Plant your feet, even to the point of tracing your footprint on the floor to know where to return to after you take a break. Don't dance around when you draw!

- Practice rotating your full arm, with elbow locked, from the direction of the subject matter to your paper, moving only the shoulder joints, like the hinge on a door.

FIGURE 5–1

Student at easel with arm extended to drawing
Photo Courtesy of Carla Rae Johnson. Model: Ana Santos

FIGURE 5–2

Student at easel with arm extended to subject
Photo Courtesy of Carla Rae Johnson. Model: Ana Santos

- Practice holding your wrist steady, without rotating, as you move your arm from the subject matter to your paper.

- Use vine charcoal for this technique. Vine charcoal can make a line with very little pressure and can be wiped away with ease. You will need a full length of this stick of vine charcoal (not a tiny stub) for purposes of sighting.

- Establish an **anchor line** (see illustration on page 40). Find a vertical on your subject and note its length relative to your stick of charcoal. Record this vertical line on your paper. Here are some important guidelines to drawing an anchor line:

 1. A vertical line is always selected to be the anchor line because verticals always remain vertical (parallel to the right and left sides of your drawing paper). The angles you will record are the diagonals of planes moving away from your eye and the horizontals that are parallel or nearly parallel to the top and bottom of your drawing paper.

 2. You will need to estimate the length of this anchor line as it relates to how the whole of the composition will fit on your drawing format. This anchor, line as you lay it on the paper, is the only time that you estimate something; every other line recorded on your paper is located through this angling and measuring system. The length of every other line is determined by its relative length to your anchor line.

 3. Refer to thumbnail sketches to position and estimate the length of your anchor line. Note: This means that the length of your drawn anchor line will almost surely *not* be the same length as your charcoal stick. You will always be working with comparisons of lengths as you employ sighting techniques.

Anchor line: Used to "anchor" you in a fixed point of view. It is a vertical length you have selected from the subject and transferred to your drawing paper using the relative length of your drawing tool as a measure. The length of the vertical on your drawing paper is likely to be different than the length you saw on your drawing tool (when held up to the anchor on your subject), but it should be **proportional** to the original. Return your drawing tool to the anchor line on your subject often to re-establish your fixed position. When the anchor length matches the original length on your drawing tool, you will know you have returned to that fixed position. Once the anchor line has been established, every other linear length will be **relative** to that length. It is important to remember that you are not "measuring" lengths as much as you are "comparing" them to each other.

- Use the anchor line to return again and again to your original fixed point of view: Maintain the extended, locked-elbow, arm's-length distance from your vertical drawing surface. Each time you have to move, reposition yourself by checking the relationship of your anchor line (the vertical length you identified in your subject) to its length on your charcoal stick.

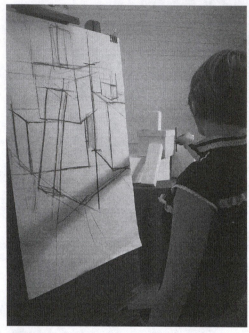

FIGURE 5–3
Hand and charcoal on anchor line of subject
Photo Courtesy of Carla Rae Johnson.
Model: Ana Santos

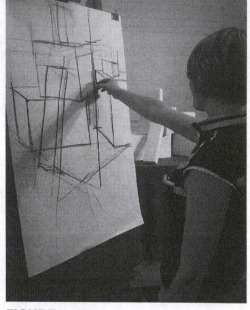

FIGURE 5–4
Hand and charcoal drawing anchor line on paper
Photo Courtesy of Carla Rae Johnson.
Model: Ana Santos

The importance of easel position – just as important as a fixed point of view is the position of your easel in relation to the subject. The vertical easel, at arm's length and positioned at a 45-degree angle to your subject, is essential to efficient and comfortable sighting and drawing. **Keeping your drawing surface vertical is crucial:** This position eliminates drawing distortions as your eye moves from subject to drawing maintaining a vertical orientation.

- Adjust your easel to the upright/vertical position.

- Orient easel to a 45-degree angle to the subject matter, so you only have to glance with your eyes, not rotate your body or head. This also allows for your eyes to move rapidly from drawing to subject to do constant comparisons.

- Make sure your dominant (drawing) hand/arm points toward the subject (not across your body, which would be awkward). This is important because the position allows you to rotate with ease from subject to drawing surface to sight, check, and record what you see.

- Place your paper at eye level and on your dominant side (to the right if you are right-handed, to the left if you are left-handed).

- Have ALL your needed drawing supplies accessible in the easel tray. Stopping to search through your box of supplies will not only necessitate re-establishing your fixed point of view, but also break your concentration.

Sighting Angles

- Select an angle (for example the straight edge of a receding plane) and rotate the drawing tool (vine charcoal) like the hand of a clock or a windshield wiper to match the angle. **Do not point toward the subject!**

- Holding the charcoal at the angle, freeze everything. Moving only your shoulder joint, swing your extended arm back to touch your drawing paper and record that angle on the paper. When you rotate your arm back to the drawing board, your charcoal should be parallel to the board. If the charcoal is pointing at the board, you have recorded the angle incorrectly (as this is an indication that you pointed and didn't rotate the charcoal to find the angle). Extend the line well beyond the edges of the object. (You will soon learn how the extended line will become important to your sketch and your drawing's accuracy.) As you work on this "extended-line" sketch, use very little pressure to make a light line. You can easily wipe away a lightly drawn line if you need to make a correction. When you are sure that the angle and length of a line is correct, you can always darken it to see it better.

- Repeat this sequence to double-check that the angle is accurate. Always double-check your angles. With practice, this will become easy, quick, and natural and will help you to make corrections before you are committed to an angle in the drawing process.

- Record all angles of your subject with this sighting technique. Record each one, extend the lines, and double-check for accuracy.

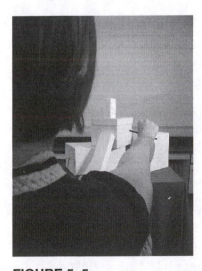

FIGURE 5–5
Hand and charcoal angled
with subject
Photo Courtesy of Carla Rae
Johnson. Model: Ana Santos

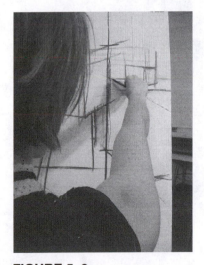

FIGURE 5–6
Hand and charcoal lined up with
angle in drawing
Photo Courtesy of Carla Rae
Johnson. Model: Ana Santos

FIGURE 5–7
Extended line meeting landmark on drawing
Photo Courtesy of Carla Rae Johnson.
Model: Ana Santos

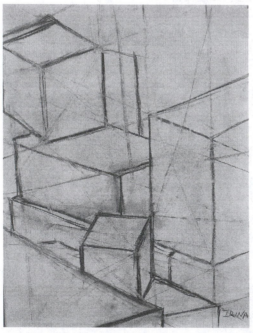

FIGURE 5–8
Extended-line drawing with sighted angles by Irina Climovici
Photo Courtesy of Carla Rae Johnson

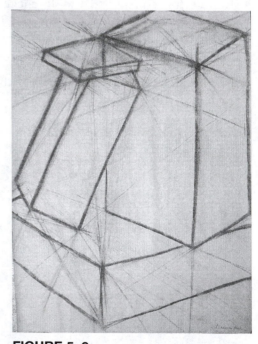

FIGURE 5–9
Extended-line drawing with sighted angles by Lauren Helms
Photo Courtesy of Carla Rae Johnson

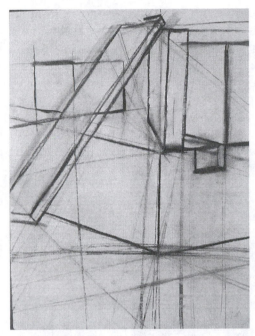

FIGURE 5–10
Extended-line drawing with sighted
angles by Lenoard Hidalgo
Photo Courtesy of Carla Rae Johnson

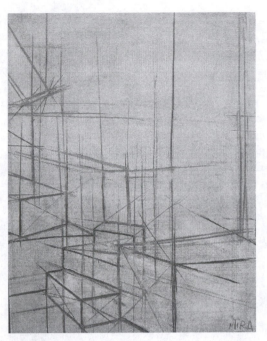

FIGURE 5–11
Extended-line drawing with sighted
angles by Vladimira Pipova
Photo Courtesy of Carla Rae Johnson

- Use the extended portions of each angle line to check to see if it meets up with any other landmark in your subject (and, thus, in your sketch). This aspect of sighting technique can save you time by helping you to locate many objects, corners, edges, and other significant "landmarks" in your subject and your drawing.

Comparing/Measuring Proportions

- **Use your anchor line.** Your anchor line can be useful beyond its original function to keep you anchored in position. Use the length of your anchor line to compare it to other lengths you observe in your subject. To do this, move your thumb along the length of your charcoal stick, matching it with a length you see in your subject. **Be certain** to maintain your fixed point of view as you make comparisons and move back and forth from the subject to your drawing surface.

- **Compare and compare and compare!** Check and compare each object, edge, section, space, height, width, and length you see in the subject. Make these same comparisons on your sketch. The time you spend doing this is a worthwhile investment. It will pay dividends in the accuracy of your finished drawing. Mastery of this technique will also prove vital to your skill level later when you approach the human figure. The complex proportional relationships of the figure will not be so difficult to record if your sighting techniques are well developed.

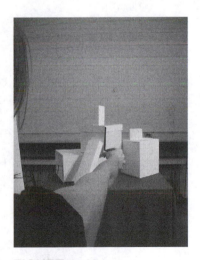

FIGURE 5–12
Thumb on vine charcoal to
measure object
Photo Courtesy of Carla Rae
Johnson. Model: Ana Santos

Point-to-point: A technique that joins the points, corner to corner, of any rectangular plane (in particular, that of a plane receding in space) with a lightly drawn extended line. Point-to-point is a technique used to check for accuracy in sighting perspectives. If the angles of the lines that link corners in your drawing match the angle you sight directly from the subject, it indicates that the sighting at the edges of that rectangular plane is accurate. If the angles don't match up, do the sighting again to pick up any inaccuracies.

- **Use the point-to-point technique.** A helpful addition to your methods of sighting techniques is called **point-to-point.** This technique is just what it sounds like: joining points to other points. Line up one end of your charcoal stick from one point, a landmark such as the corner of a box, the top-center edge of a plane, or the point at which one object touches another—any defined point you can identify in the subject you are observing. Bring your charcoal to an angle matching a line extending to any other point you identify in the subject. Move this angle (of your charcoal stick) to position over your drawing paper to locate the angle relationship of the two points on your sketch.

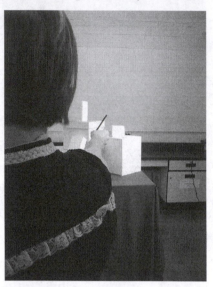

FIGURE 5–13
Point-to-point angle of charcoal to subject
Photo Courtesy of Carla Rae Johnson. Model: Ana Santos

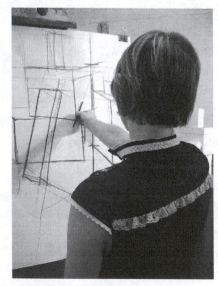

FIGURE 5–14
Point-to-point angle of charcoal to drawing
Photo Courtesy of Carla Rae Johnson. Model: Ana Santos

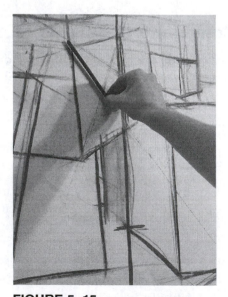

FIGURE 5–15
Point-to-point on corners of receding plane on drawing
Photo Courtesy of Carla Rae Johnson. Model: Ana Santos

- **Also use point-to-point technique to check for accurate angles.** By sighting an angle from one corner to another of any plane (the receding plane on the side of a rectangular box, for example), you can detect inaccuracies in your sighting of the angles and make corrections as needed. This is one of the most useful things about the **point-to-point** technique! Use it often and the perspective of your sketches and subsequent drawings will be much more accurate.

- **Use a different technique to measure rounded objects.** Depicting rounded objects, such as vases, spheres, fruit, cylinders, and other objects with curvilinear surfaces, can be a challenge to students learning to draw. The following technique may help you to record these kinds of objects more accurately in your sketches and drawings.

 1. **Drop a plumb line:** Using your anchor line as a comparative length to establish the height of the object, draw a vertical **plumb line** that will represent a vertical central axis for the object.

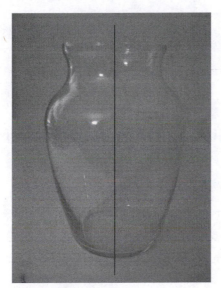

FIGURE 5–16
Vase with plumb-line
Photo Courtesy of Carla Rae
Johnson

 2. Compare/measure widths at top, bottom, and widest point in your rounded object to the length of your plumb line. Draw horizontal lines to the measured lengths along the vertical plumb line you have established.
 3. Note the relationship of all parts of the object to your eye level. Is it at eye level? Is it below or above eye level? The relationship to your eye level will affect the proportions of the **ellipses** you draw to fill out the form(s) of the object.
 4. Draw the object as if it is transparent. You should be able to see through the object to its back; thus, you will see the ellipses at top, bottom, and throughout the widest and thinnest portions of the form.

Plumb line: An imagined vertical line down the center of an object. The term *plumb* refers to a pure vertical. The term probably comes from carpentry and building. Builders use gravitational pull on a "plumb-bob" (a heavy pointed object suspended at the bottom of a plumb line) as a guide to determine a "true vertical" for a wall or corner. The plumb line you imagine and draw will be parallel to the sides of your drawing paper. Plumb lines can help you draw equal shapes on either side of a symmetrical object, or equitable shapes on either side of an asymmetrical object.

Ellipses: An oval that the eye sees when any cylindrical object is viewed from the side (as opposed to looking straight down into a cylinder, in which case you will see a circle). Ellipses change in width as your eye level changes. Farther above or below eye level, ellipses will be "fatter" ovals. As the top of a cylinder nears eye level, the ellipse flattens out. At eye level the top of a cylinder appears to be a straight line.

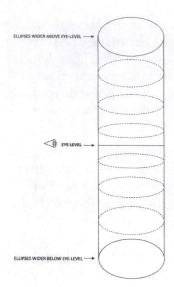

FIGURE 5–17
Cylinder ellipses at eye-level,
above, and below
Courtesy of Carla Rae
Johnson

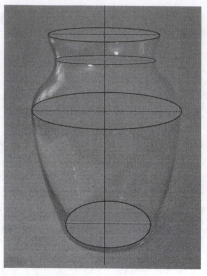

FIGURE 5–18
Vase with plumb-line and ellipses
Photo Courtesy of Carla Rae
Johnson

Volumes Sketch: A specific type of sketch that uses the angling, measuring, and point-to-point techniques described in this chapter. In a volumes sketch, objects are drawn as if they are transparent. Extended lines, anchor lines, plumb lines, point-to-point lines, ellipses, and cross-contours are used to compare proportions and to create the perceptual illusion of volumes and space.

Combining Sighting, Angling, Measuring, and Point-to-Point Techniques

Figure 5-19 combines the sighting techniques we have discussed in a sketch that reveals volumes, proportions, and spaces. We call it a **volumes sketch** because the techniques reveal the volumes of the objects. Use it as a quick, visual reference whenever you practice these techniques.

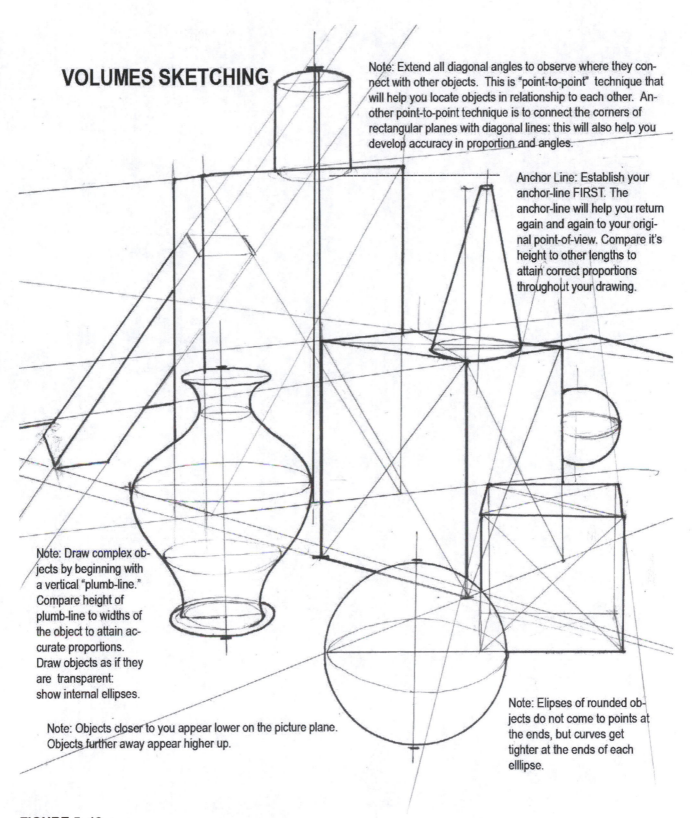

VOLUMES SKETCHING

Note: Extend all diagonal angles to observe where they connect with other objects. This is "point-to-point" technique that will help you locate objects in relationship to each other. Another point-to-point technique is to connect the corners of rectangular planes with diagonal lines: this will also help you develop accuracy in proportion and angles.

Anchor Line: Establish your anchor-line FIRST. The anchor-line will help you return again and again to your original point-of-view. Compare it's height to other lengths to attain correct proportions throughout your drawing.

Note: Draw complex objects by beginning with a vertical "plumb-line." Compare height of plumb-line to widths of the object to attain accurate proportions. Draw objects as if they are transparent: show internal ellipses.

Note: Objects closer to you appear lower on the picture plane. Objects further away appear higher up.

Note: Elipses of rounded objects do not come to points at the ends, but curves get tighter at the ends of each elllipse.

FIGURE 5–19
Courtesy of Carla Rae Johnson

Chapter 6

Value

What Is Value?

In drawing the term *value* refers to the lightness or darkness of a tone. A full range of value extends from white, through infinite gradations of grays, all the way to black. Although the scale to the right has only seven sections, it is possible to have a much larger range of grays than this scale demonstrates.

The introduction of value to a drawing allows the artist to create the illusion of light as it describes volume, space, and texture. Light is what allows you to see forms. In an absolutely pitch-black room with no light source, you cannot see anything or distinguish any forms. As soon as a light is turned on, you can see forms and objects in the room again. Being able to see the forms is the result of the forms absorbing or reflecting light. The amount of light the forms absorb or reflect is determined by two factors:

- the physical relation of the object to the light source (the surface of the object facing the light source will appear the brightest, the surface of the object turned away from the light source will appear the darkest)

- the **local value** of the object, or the inherent color of the object (a black object will absorb more light and reflect less light, therefore appearing darker than a white object that absorbs less light and reflects more light).

When working from direct observation, there are two possible light sources: natural light or artificial light. Natural light comes from the sun and therefore changes as the sunlight changes direction throughout the day. If you're setting up a still life near a window for the natural light, be aware that the light will drastically change according to the time of day. Artificial light comes from an electric light source, most often either incandescent or fluorescent. Using artificial light offers the artist more control over the lighting situation. The artist can choose the direction and intensity of the light. A strong single light source coming from one direction (rather than ambient lighting) will create sharp changes of value and clearly defined cast shadows. The intensity of a single light source makes it easier to see the changes of value and can be beneficial to the student who is learning to draw.

Materials for Charcoal Value Drawings

Charcoal is a great medium for beginning students because of its flexibility and forgiving properties. Charcoal can articulate a wide range of value, making it an ideal medium for value drawing as well. The flexibility of the material allows the artist to easily blend, smear, and erase. The following

Value: Lightness or darkness of a tone.

Local value: The inherent value of an object as a result of the color of the object, regardless of the amount of light the object receives (i.e., purple is darker than yellow).

FIGURE 6–1
Value scale with six steps.
Courtesy of Carla Rae Johnson

49

materials will be necessary for value drawings (for additional information and photos of each medium, see Chapter 1):

- *Vine charcoal* – its softness, flexibility, and ease in erasing make it a great material for gesture drawings and for the sketch at the start of a drawing when a lot of erasing and corrections take place. Vine charcoal has limitations, however; it is not possible to achieve a black value with vine charcoal and the ease with which it can be erased makes it a temporary material.

- *Compressed charcoal* – has a denser consistency than vine charcoal and as a result is a bit more difficult to erase. Compressed charcoal is capable of achieving a wider range of value than vine charcoal. Compressed charcoal can create a very deep, velvety black. Once you have achieved accuracy in your drawing using vine charcoal, you should begin using compressed charcoal to achieve a wider range of value.

- *Spray fixative* – (workable fixative) is used to "fix" or bond charcoal to the paper. Although this fixative is workable, after spraying your drawing it can be difficult to erase back to the white of the paper. Charcoal drawings should be sprayed after completion, particularly before transporting them. The fixative helps to prevent the charcoal from smearing during transportation. Be careful when using spray fixative as it is a toxic material. Only use spray fixative outside or with good ventilation.

- *Artgum eraser* – is a good eraser with charcoal, although it can be crumbly and a bit messy. Small pieces of this eraser can be easily broken off to create an edge or corner for detailed erasures.

- *Plastic/vinyl eraser* – is a good multipurpose eraser that works well with charcoal.

- *Click eraser* – is a vinyl eraser that looks like a ballpoint pen. The small tip of this eraser makes it a great tool for creating erased lines and for erasing small spaces in your drawing.

- *Blending stumps* – are made from paper that has been tightly rolled or compressed into a pencil like form. Blending stumps can be used to blend and smear charcoal and to create a flat plane of value.

- *Chamois* – (pronounced *sham-ee)* is a thin piece of suede used with charcoal. A chamois is a multipurpose tool that can lighten, darken, and erase charcoal. When your chamois is loaded with charcoal, it can create a *ground* quickly and easily. By wrapping a chamois over your finger and "finger drawing," it can become a drawing tool as well.

- *Soft cotton cloth* – such as a piece of teeshirt material, is useful for blending charcoal without removing it (unlike a chamois).

- *Charcoal drawing paper* – is a durable paper with a pronounced *tooth* (texture) that allows it to receive and hold the charcoal. The durability of this paper makes it capable of handling a lot of erasing. Drawing

paper that is 100% rag is more expensive but will erase to a cleaner, brighter white, thus providing a more dramatic range of values.

Creating Edge through Change of Value (No Line)

Line is a fundamental element in drawing. It can be used to describe form, texture, and weight. However, there is no line in real life. When working from direct observation, the subject you are attempting to draw is not made up of line. It is a three-dimensional form on which there are changes of value according to the direction and amount of light it receives. When an artist uses line, it is often to describe edge. But an edge can be described by the meeting of two different values, without line. Value can be a dynamic vehicle for creating drawings that articulate the illusion of form and space. On the contrary, a heavy line describing the outside contour of forms can actually work to flatten the form out, much like a cartoon. A heavy outline works against the creation of form and space (see Figure 6-3).

Figure 6-2 illustrates the change of value that occurs on the three visible sides of a box when it is lit with a single, direct light source. The side of the box with the lightest value is directly facing the light source, the side of the box with the middle value receives some light but not directly, and the side of the box with the darkest value is facing away from the light source and receives the least amount of light. Notice that when the value changes at the edge of the box it is a hard, abrupt change of value, with clearly defined edges.

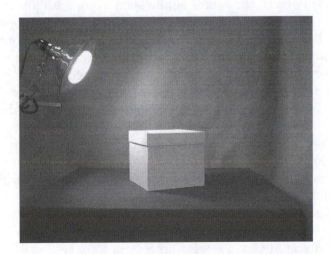

FIGURE 6–2

Box lit with a single direct light source, demonstrating the resulting value changes.
Photo Courtesy of Laurie Steinhorst

Figure 6-4 is a value drawing of a box. The artist has described the form by creating three planes, each with a different value. The place where the two different values meet describes the edge. Notice that at the point when the two different values meet (the edge of the box), the artist has taken great care to create a crisp and clean edge. The artist has created a smooth plane of value on each side of the box, removing any streaks of charcoal by carefully rubbing the charcoal into the surface and carrying the value precisely to the edge of each plane.

FIGURE 6–3
Drawing and Photo Courtesy of Laurie Steinhorst

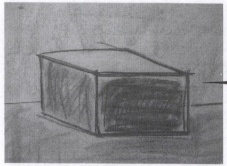

DON'T USE LINES TO DEFINE EDGES IN A VALUE DRAWING. HEAVY OUTLINES WORK AGAINST THE ILLUSIONS OF FORM AND SPACE

FIGURE 6–4
Drawing and Photo Courtesy of Laurie Steinhorst

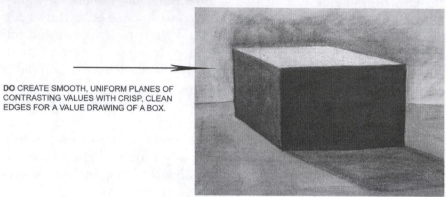

DO CREATE SMOOTH, UNIFORM PLANES OF CONTRASTING VALUES WITH CRISP, CLEAN EDGES FOR A VALUE DRAWING OF A BOX.

Value gradation: When a value change from light to dark occurs slowly, evenly, and gradually.

Shading: Producing a gradual value change from light to dark in an object in an effort to create an illusion of three-dimensional form.

Chiaroscuro: A technique of producing a gradual value change from light to dark in an effort to create an illusion of three-dimensional form.

Value Gradation (Rounded Forms)

An abrupt change of value indicates a hard-edged, angular object, but for a rounded object, the value change occurs quite differently. Because of the curved nature of the form, the value changes happen slowly, evenly, and gradually as the form moves toward or away from the light source. A slow, gradual change of value is referred to as **value gradation, shading,** or *"chiaroscuro."* A gradual, even change of value is achieved by either varying the pressure placed on the charcoal or by applying a layer of charcoal then blending and smearing it with a blending stump, a soft cloth, a chamois, or your fingertips and continuing to gradually add or remove charcoal to lighten or darken the surface. All of the materials mentioned to blend or smear charcoal produce a slightly different result. Through experimentation you will become familiar with the various possibilities and develop an understanding of the material that best suits your needs.

Figure 6-6 illustrates the slow, gradual change of value that occurs on a rounded object lit with a single, direct light source.

Figure 6-7 includes two value drawings of the rounded object in Figure 6-6. In the first drawing the value change is abrupt, destroying the sense of a rounded surface. The drawing also uses harsh outlines that flatten the forms. In the second drawing the artist has described the rounded form by gradually changing the value from the lightest part where the form is directly facing the light source and then slowly and gradually (by blending and smearing the drawing medium) darkening the value until arriving at the darkest area where the form is farthest from the light source. Notice that the artist has taken great care to eliminate any abrupt change of value but instead creates a gradual soft feel to the value change, creating the illusion of a rounded form.

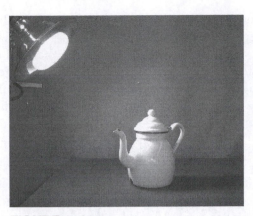

FIGURE 6–6
Rounded object lit with a single direct light source.
Photo Courtesy of Laurie Steinhorst

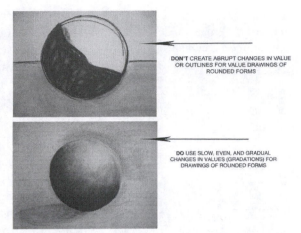

DON'T CREATE ABRUPT CHANGES IN VALUE OR OUTLINES FOR VALUE DRAWINGS OF ROUNDED FORMS

DO USE SLOW, EVEN, AND GRADUAL CHANGES IN VALUES (GRADATIONS) FOR DRAWINGS OF ROUNDED FORMS

FIGURE 6–7
Drawing and Photo Courtesy of Laurie Steinhorst

Value Scale Gradation

FIGURE 6–5
Value scale demonstrating a gradual change of value.
Courtesy of Carla Rae Johnson

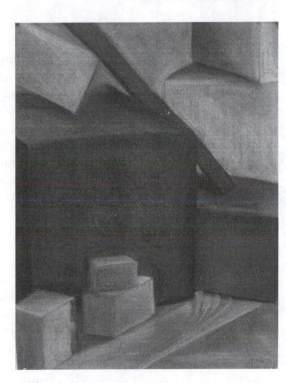

FIGURE 6–8
Student value drawing by Marina Mellinas Leva. Photo Courtesy of Carla Rae Johnson

Procedures for Value Drawing

As you become more proficient as an artist, line, shape, value, and composition develop simultaneously in a drawing. For beginning students it is helpful to break the drawing process into steps:

• **Begin with a strong composition.** As with the other technical approaches to drawing discussed in this book, a good value drawing begins with a strong composition. Use your viewfinder to create several thumbnail sketches working through compositional possibilities until you arrive at a composition that is balanced, has dynamic positive and negative spaces, and visual flow. Remember, a good composition deals with the entire surface of the picture plane!

Ground: Preparing a two-dimensional surface by applying a thin layer of charcoal, creating a flat middle value grey that covers the entire picture plane.

FIGURE 6–9
Student value drawing by Lauren Helms.
Photo Courtesy of Carla Rae Johnson

FIGURE 6–10
Student value drawing by Kaylene Morgan.
Photo Courtesy of Carla Rae Johnson

- **Prepare.** Prepare a sheet of good quality 18 × 24-inch charcoal drawing paper with a middle value **ground.** This can be done quickly and easily by wiping a chamois loaded with charcoal over the surface of your drawing paper. Carry the ground to the edges of the picture plane, creating a smooth even surface of value void of texture. Working with a ground encourages you to see and draw the light values as well as the dark values.

- **Begin.** Using the thumbnail sketch as a guide, begin your drawing. You may begin using vine charcoal or drawing with your eraser, erasing lines into the ground. A lot of erasing and redrawing takes place in the beginning of the drawing to arrive at accuracy in shape relationships and angling. Work quickly at this stage of the drawing, concentrating on large basic shapes and working over the entire surface of the picture plane. Make use of the angling and measuring technique discussed in Chapter 5 to arrive at the correct relationship of shapes and angles.

- **Establish the range of values.** Once you have arrived at a strong level of accuracy in your drawing, you can begin adding value with your compressed charcoal. The first step when adding value is to *squint* your eyes and look at the still life. Squinting your eyes will clarify the value relationships, allowing you to see the value differences more dramatically and eliminate unnecessary details. With your eyes squinted, locate the darkest dark in the still life. Place this black value shape in the appropriate place in your drawing using compressed charcoal. With your eyes still squinted, locate the lightest light in the still life. Place this light value in the appropriate place in your drawing by erasing into the ground. You have now established the lightest light and the darkest dark in your drawing. Establishing these two values that exist at the extreme ends of the value scale will help to ensure a wide range of value in your drawing and can act as a gauge by which you can compare all other values.

- **Add in-between values.** Now you will begin adding mid-range values, making sure that nothing in the drawing gets as dark as your darkest dark and nothing gets as light as your lightest light. Observe the values of both the positive and negative spaces. Continue to *compare values to each other.* Only through the process of comparing and contrasting values can you arrive at the correct value relationships. Use both your compressed charcoal to add darks and your eraser(s) to erase out the lights. Remember, your eraser is a drawing tool, not just a tool to remove mistakes.

- **Always work from general to specific,** seeing and drawing the big value shapes first. Continue to squint your eyes as this will allow you to see the overall underlying value relationships more easily. Opening you eyes wide will allow you to see the more subtle value changes. Your job as an the artist is to act as an editor, deciding what elements of the still life are significant enough to include in your drawing and what can be left out. Your drawing will *not* include every detail in the still life. Instead, your drawing need only include the information that will help the viewer's eye read the form and space. Knowing what is important to help the eye read the form and what is insignificant detail comes from experience and experimentation.

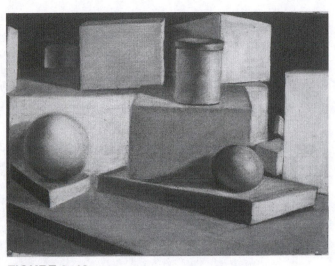

FIGURE 6–12
Student value drawing by Keith Greenbaum.
Photo Courtesy of Carla Rae Johnson

FIGURE 6–11
Student value drawing by Lisabeth Briggs.
Photo Courtesy of Laurie Steinhorst

FIGURE 6–13
Student value drawing by Gayle Malheiro.
Photo Courtesy of Laurie Steinhorst

FIGURE 6–14
Student value drawing by Alba Arellano.
Photo Courtesy of Laurie Steinhorst

Cast shadow: A shadow created when an object is strongly lit; the shadow created is cast onto surrounding objects.

- **Include cast shadows as an important part of your drawing.** Draw **cast shadows** with as much care as any other object in your drawing. Closely observe the shape and the value of the cast shadows. Cast shadows communicate information about both the form that is casting the shadow and the form onto which the shadow is cast. Because cast shadows move with the form onto which they are cast, they can help to describe that form.

- **Be mindful of edges.** Sharp edges indicate a hard-edged, angular form. When edges are hard, take the care to make them crisp and clean. Soft edges indicate a rounded form. When forms are rounded, take the care to make the value gradation soft and gradual. Works toward eliminating any heavy linear outline of forms. The heavy outline of forms only works to flatten out the form. Instead, let the edges be described by two different values meeting one another.

- **The larger the value difference, the deeper the space.** Don't forget about the negative space or "background." Negative space has a shape and value that is as important as any other element in your drawing. In order to create a sense of deep space, exaggerate the value difference between an object and the surrounding background. It is better to overstate value differences than to understate them.

- **Step back from your drawing periodically.** Establishing a distance from your drawing offers a different perspective that allows you to see the drawing in another way, picking up distortions and imperfections that you cannot see close up. If you find it difficult to pick out the forms from a distance, your drawing lacks an adequate amount of value range.

- **Continue to refine your drawing.** As you work into a drawing, your vision will become more precise. As a result, you will pick up mistakes that you didn't see at first. Continue to correct your mistakes as you become aware of them, constantly changing and perfecting the drawing. Don't be concerned that the eraser marks might be visible. These marks will not appear "messy." They are evidence of the activity and struggle of the artist and can lend an very exciting energy to the surface of the drawing.

- **Don't rush.** Creating a strong value drawing takes time, concentration, and focus. Move slowly and precisely, adding details gradually as the drawing develops. The drawing should develop as a whole, not overdeveloping any one area of the drawing over another.

- **Keep your attention moving all over the picture plane.** Don't get stuck in any one area. The objective should be to create a sense of unity and wholeness in the drawing. To accomplish that objective, you must see and draw it as a whole.

Chapter 7

Mark-Making and Texture

Many people would define drawing as a sophisticated sort of "mark-making" in which the artist makes marks on paper in reference to what he or she sees. You now know that drawing skill relies as much on the artist's power of observation as it does on skill in making marks on paper. Since you have worked to develop strong skills in observation, it is now time to focus on the act of making meaningful and interesting marks on your paper surface. By "meaningful marks" we mean marks that by their nature—size, shape, texture, edges, direction, character, and combinations—echo or suggest the forms, contours, and surfaces of the observed object to which they refer. By "interesting marks" we mean a variety of line qualities. Lines and marks can vary in weight, pressure, value, texture, length, and direction. They can also be broken, continuous, irregular, curved, straight, **calligraphic,** anxious, graceful, rhythmic, bold, or timid and thus suggest any desired mood or emotional state the artist may choose. Drawing objects accurately (accurate proportions, perspective, contours, and surrounding negative spaces) is important, but your drawings only really "come to life" when the marks and lines you use to suggest forms and spaces are varied, visually interesting, or personal and can move the eye in and through your composition.

Why Are Varied and "Meaningful Marks" Important?

- Although some fine drawings intentionally have little variation in line and mark, most drawings hold a viewer's interest by having some variety in the weight, thickness, and quality of their lines. In Chapter 2 on composition, you learned that repetition with variation creates a sense of interest and harmony. This holds true for the system of lines and marks you create on your drawing paper. Without variety, you run the risk of boring your audience. Without any repetition, you run the risk of creating a perception of chaos or lack of order. Finding a balance between these two forces is part of the challenge and excitement of drawing.

- Making marks on paper can be uniquely your own, much like a signature. Mark-making can, and perhaps **should**, become quite personalized. This is really the beginning of developing your own style as an artist. Graffiti artists become known when they move beyond learning "technique" and begin to create work that has a personalized signature style. In the same way, artists who continue to draw eventually become

Calligraphic: The term *calligraphy* refers to handwriting or script in letters and words. Many cultures have developed systems of lines and marks for the written language. These marks often have subtle line variations and beautiful rhythms of lines and spaces. Calligraphic lines use rhythmic repetitions and varied lines (lines with different weights, thicknesses, and lengths) that suggest the elegance of calligraphy.

sensitive to their own intuitive responses to subjects and allow those responses to move through their arms, hands, and fingers to the drawing tool and onto the paper. When intuition hits your paper, it feels as if it is flowing through you onto the surface.

- Artists should avoid "sketchy" or "scribbled" lines and marks. Meaningful marks and intuitive lines are the opposite of scribbles or "sketchy" kinds of line. The scribble is a mindless repetition of loops and scratches that have no relationship to a subject. (We don't mean to disparage the act of scribbling for its own sake. Very young children scribble for the pure joy of making a record of movement. Some contemporary artists evoke this same state in their drawings.) The focus of an introductory course in drawing, however, is upon line and mark-making as they relate to direct observation of forms and space. Your lines and marks should be in response to what you observe. Students often believe that a sketchy line is "the way to draw." The sketchy line is created by a broken, back-and-forth movement that is very self-conscious and unsure of itself. Sketchy lines convey: *"I don't know where I should be or what I should look like, so let me go back and forth while I decide."* If you find yourself slipping into a habitual "sketchy-line" mode, focus on following the contours and cross-contours of your subject. When your eye and your hand begin to work in sync with each other, you will remember the connection between drawing and observation, and you will renew confidence in your own ability to connect the line on your paper to the subject you see.

Creating Value with Marks (No Blending or Smearing)

When marks and/or lines are multiplied on the surface of your drawing paper, they can begin to suggest areas of different values. The more marks or lines added to a particular area of your paper, the darker that area will appear. Thus, you can create the full range of values in a drawing composed of only lines and marks. Some media—pens and markers, for example—do not lend themselves to blending. Artists use them to create distinct, crisply contrasted edges each time they touch the paper surface. Over the centuries artists have experimented with and developed seemingly endless ways to use these media with systems of lines and marks to create values, shading, and gradations. You can experiment to develop your own systems that do the same.

Media for creating value with marks/lines – Media for this drawing technique include a variety of felt-tip markers (broad, fine, ultra-fine), brush markers, calligraphy markers (see Figure 7-1), pens with a variety of nibs and used with India ink, and graphite pencils (though the graphite **can** be blended, you should avoid blending or smearing for this kind of drawing). Only the build-up of multiple lines and line thickness will be available to you to create a full range of values.

FIGURE 7–1
Photo Courtesy of Carla Rae Johnson

Value-scale with marks/lines – You can get some practice that will help you understand and apply this technique by creating value-scales using a system of lines or marks in your sketchbook. You can create stepped value-scales and gradation value-scales in this way. Here's an example of each of these:

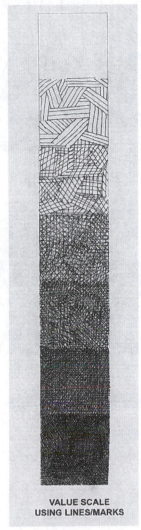

VALUE SCALE
USING LINES/MARKS

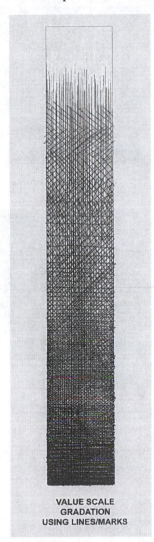

VALUE SCALE
GRADATION
USING LINES/MARKS

FIGURE 7–2
Drawing and Photo Courtesy
of Carla Rae Johnson

FIGURE 7–3
Drawing and Photo Courtesy
of Carla Rae Johnson

Variety of line systems – The ways to combine similar or varied lines to create values are almost infinite:

- A system of lines running along cross-contours of an object, called *contour hatching*

- A system of dots, called *stippling*

- A system of parallel lines/marks, called *hatching*

- A system of crisscrossed lines, called *cross-hatching*

These are just a few of the systems traditionally used by artists to build up values without blending. On the following page we have provided a few samples and left some spaces for you to develop your own unique systems to create values and gradations.

Shading Techniques Using Line and Mark

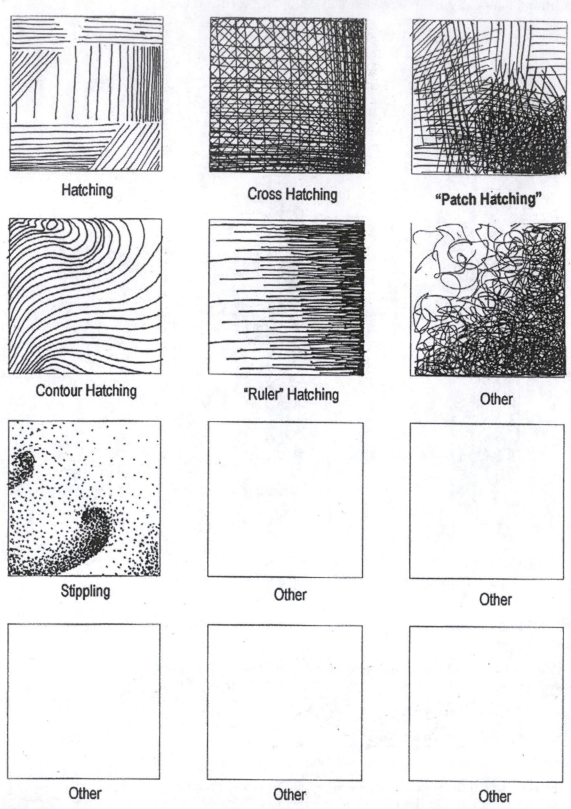

FIGURE 7–4

Drawing and Photo Courtesy of Carla Rae Johnson

Creating Gradations in Value with Marks/Lines

Just as you can build up the full range of values by controlling the density of marks and lines in your drawing, you can also increase/decrease the density of marks and lines **gradually** to create value gradations. In the previous exercise, you developed systems of lines and marks to create values. If your systems did not create value gradations, go back over them to add lines/marks to "build up" values and create a smooth gradation from the lightest shade to the blackest black you can achieve.

- **Value contrasts and gradations.** In your drawings you can use marks and lines to develop value contrasts to reveal the edges of planar forms or value gradations to suggest curved surfaces and volumes.

- **No blending.** Unlike charcoal or graphite, the medium you are using will not lend itself to blending, smearing, or a smooth transition from one value to the next. You will rely on the ability of the eye and mind to "translate" a density of marks/lines into darker or lighter areas.

- **Building up.** We use the phrase *build up* when we are discussing techniques of creating values exclusively with marks and lines. Particularly with gradations, this is done by adding marks on top of each other to build up darker and darker values. If this is done carefully (with the mark or line system you are using) and you move from very few marks/lines to more and more, you will create the appearance of gradation and, thus, the illusion of a curved surface or rounded form.

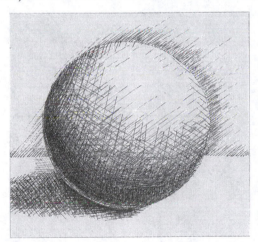

FIGURE 7–5
Value gradation suggesting rounded form by build up of lines or marks. Drawing and Photo Courtesy of Carla Rae Johnson

Creating Texture with Marks/Lines

Another skill that will enhance your drawings is to draw surfaces and textures convincingly. A variety of textures will add to the visual interest of your drawings. Systems of marks and lines are a very effective way to create a variety of textures on your drawing surface. Here are some suggestions that will help you develop visually interesting textures in your drawings.

- **Use tactile textures:** A texture that can be felt when you touch is called a tactile texture.

- **Use visual textures:** A texture that *appears* tactile (through an illusion created in a drawing or a photograph) is called a visual texture.

Texture: The character, feel, or quality of a surface. A texture can be perceived either by touching or seeing. Your fingers on a brick wall feel the irregular, bumpy, rough texture of the bricks and mortar. Directional light can reveal the texture of a surface to the viewer's eye.

Tactile texture: A tactile texture is a surface that you can feel. (The term *tactile* refers to the sense of touch.)

Visual texture: A visual texture is a surface that *appears* to have tactile qualities, but does not. It is purely visual. A photograph of a textured surface and the image of a texture on the page of a magazine are examples of visual textures.

- **Explore visual and tactile textures:** These textures are infinite in variety and might include rough, smooth, pebbly, jagged, slimy, dry, abrasive, squishy, woven, sticky, downy, irregular, furry, scaly, shiny, crusty, spongy, pierced, prickly, fluffy, bumpy, or metallic. This is a **short** list! You can think of hundreds of other adjectives describing textures, but it's better to find and draw than to just list them!

- **Experiment with rendering:** In your drawings, you will explore ways to create the **illusion** that your visual textures evoke a tactile experience. Creating the illusion that a visual texture in your drawing is very "real"—that the viewer could actually **feel** that texture if he or she reached out and touched your drawing surface—is called rendering a texture.

- **Explore different ways to render textures:** These effects can be accomplished through systems of lines/marks you invent that closely resemble the patterns of lights and darks on the tactile textures you see in your subjects. You may need to explore more than one system of marks and/or lines to **convincingly render** a particular texture. In your sketchbook, you can cut and paste interesting visual textures you find in magazines or on the Internet. Next to these visual textures try several ways to use lines/marks to render each one convincingly.

> **Render:** To reproduce in a convincing way. A rendering is an extremely convincing copy of something. In a drawing called a *rendering*, the object is drawn very realistically. The process of rendering is often meticulous and carefully executed.

FIGURE 7–6
Drawing and Photo Courtesy of Carla Rae Johnson

 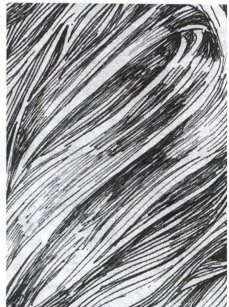

Visual Texture Rendered Texture

- **Squint!:** Remember that when rendering textures, you are actually recreating the values you see in your subject onto your paper. Therefore, as with any study of values, it helps if you squint your eyes to pick up (simplify) the basic patterns of lights and darks.

- **Employ systems:** After some practice rendering textures, you will be adept at creating systems of lines/marks to achieve convincing illusions. The visual textures in your drawings will evoke a tactile experience for your viewer.

- **Imagine textures:** In addition to rendering textures that you *see*, you can also use systems of lines and marks to create imagined textures.

These might be abstract systems of darks/lights, lines/marks that make a section of your drawing more interesting with a texture that is in contrast to other surfaces nearby.

- **Use what you know:** Of course, you can also render textures with charcoal, chamois, stomps, and erasers. Since you are familiar with these media, you will find that you can easily use them for rendering textures in future drawings.

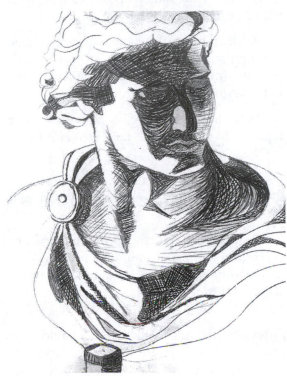

FIGURE 7–7
Student Drawing Using Lines and Marks by
Colin Pressler.
Photo Courtesy of Laurie Steinhorst

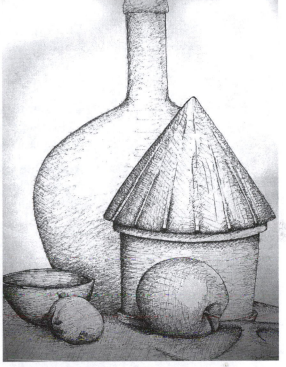

FIGURE 7–8
Student Drawing Using Lines and Marks by
Douglas Shannon.
Photo courtesy of Laurie Steinhorst

FIGURE 7–9
Student Drawing Using
Lines and Marks by
Jennifer Martinez.
Photo courtesy of Carla
Rae Johnson

Making Your Drawing with Marks/Lines

Here is the sequence of steps you should follow to create drawings using marks and lines to build up values:

- **Produce thumbnail sketches:** As with your previous drawings, you will complete a series of thumbnail sketches to develop and select a strong composition that is balanced and has dynamic positive and negative spaces and visual flow. Remember, a good composition deals with the entire surface of the picture plane!

- **Block in basics:** Use a soft graphite pencil to block in the basic shapes, working over the entire drawing surface and seeing it as a unified whole. When the values of your drawing have been completed with your mark-making medium these graphite lines can be erased.

- **Use sighting techniques:** Make use of the angling and measuring technique discussed in Chapter 5 to arrive at the correct relationship of shapes and angles.

- **Add values:** Once you have arrived at a level of accuracy in your drawing and feel you have a strong composition, you are ready to begin adding value.

- **Squint:** As you have learned, the first step is to squint your eyes to observe the variations and relationships of values. Make note of where your darkest darks and lightest lights occur. Continue to make value comparisons as you build up the values in your drawing composition.

- **Plan ahead:** Unlike your previous drawings in which you could wipe away and erase values to change your composition and your arrangement of lights and darks, creating values with marks and lines does not permit that option. Therefore, select and plan your composition from the beginning.

- **Build values:** Build up your values step by step from lightest to darkest values, leaving the darkest areas to the last. As you build up the darker values to your final areas of deepest blacks, you can control your contrasts (for visual interest and a focal point) as the final steps to completing your composition.

- **Apply techniques you have learned:** Work from general to specifics. Observe and use cast shadows. Observe and use negative spaces. Be mindful of edges. Use larger value differences to create deep space. Step back from your drawing often to observe problems of space, perspective, and value contrasts. **Don't rush.** Creating a strong value drawing with lines and marks takes time, concentration, and focus. Move slowly and precisely, adding details gradually as the drawing develops. The drawing should develop as a whole, not one section at a time. Keep your attention moving all over the picture plane, and don't get stuck in any one area. The objective should be to create a sense of unity and wholeness in the drawing. To do that, you must see and draw it as a whole.

Chapter 8
Drawing From Life

Self-Portrait

Self-portraiture is an area of figurative art that has been explored by artists for centuries. The convenience of using oneself as a model has no doubt played a role is the reoccurrence of self-portraiture in art history. But aside from convenience, there is much to be gained from an exploration of self-portraiture for the student artist. Self-portraiture can be a great entrée into figure drawing and presents many of the same challenges.

Self-portraits are one of the most interesting and compelling subjects for the artists who create them and for the viewers who observe them. A strong self-portrait, whether it is **realistic** or **abstract,** can seem like a window into the artist's mind and spirit. Some students panic when they learn they will be drawing a self-portrait thinking they will never get an accurate likeness. But the goal of self-portraiture is very different than that of a photograph. The purpose of this work is to reveal more about who you are than what you look like.

The drawing approach for self-portraiture is no different than any other we have discussed previously in this text. The only difference is that in self-portraiture *you* become the subject. The change in subject does not change the approach. You will begin by breaking the form, in this case the head, into shapes or planes (see Figure 8-1). Applying the angling and measuring technique described in Chapter 5 will assist you in arriving at the correct shape relationships. As you begin to add value, constantly compare and contrast the values on the form until you arrive at the correct value relationships.

One of the challenges with self-portraiture is the attempt to see yourself as if you were doing so for the first time, without assumptions. We have been looking at our own images all of our lives and have a developed a strict notion about what we think we look like. It can be difficult to get past that and see yourself as objectively and honestly as is necessary for drawing. It is that underlying struggle between the artist and his or her self-image that can make self-portraits such powerful drawings.

A basic knowledge of rules of proportion as they relate to the portrait can be helpful. Keep in mind that what makes us look different from one another is the difference in proportions and relationships of facial features, so these "rules" should act only as general guidelines:

- The eyes are the mid-point between the bottom of the chin and the top of the head.

- The face can be divided into thirds from the chin to the bottom of the nose, from the bottom of the nose to the eyebrows, and from the eyebrows to the hairline.

Self-portraiture: A portrait that artists create of their own image.

Realistic: A visual reproduction of the way things appear in reality.

Abstract: A visual representation of a process of simplification or distortion of visual reality.

FIGURE 8–1

Student self-portrait, breaking the form into planes by Anita Toth
Photo courtesy of Laurie Steinhorst

FIGURE 8–2

Drawing and Photo
Courtesy of Laurie
Steinhorst

PROPORTIONS OF THE HEAD

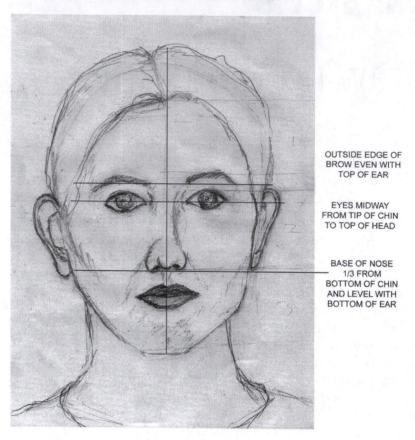

OUTSIDE EDGE OF
BROW EVEN WITH
TOP OF EAR

EYES MIDWAY
FROM TIP OF CHIN
TO TOP OF HEAD

BASE OF NOSE
1/3 FROM
BOTTOM OF CHIN
AND LEVEL WITH
BOTTOM OF EAR

- The bottom of the nose and the bottom of the ear fall on the same horizontal line.

- The outside edge of the eyebrow and the top of the ear fall on the same horizontal line.

However, many of these rules only apply to a frontal view. As soon as the head is moved in any direction, many of these rules are no longer relevant. For this reason the best approach to portraiture is to use the techniques of visual observation, including angling and measuring, discussed in previous chapters and apply them to the portrait.

Procedures for Self-Portraiture – Below is the sequence you should follow in creating a successful self-portrait drawing:

- **Make a conscious choice about the composition.** Self-portraits do not have to be a full frontal view, so make a decision about the angle from which you will view yourself. For example, the three-quarters view is a traditional way to establish asymmetry and give the head a sense of three-dimensionality. Will the portrait contain your entire face? Will you include your shoulders or part of your torso? Will the edges of your face touch, nearly touch, or go over the edges of your picture plane? What will you wear, or what props will you include? What part of the background, if any, will be included?

- **Establish a light source coming from one direction** so that one side of your face is much darker than the other. Creating strong value changes on your face will make it easier to see how the value changes describe volume and form.

FULL-FRONTAL VIEW OF HEAD

PROFILE VIEW OF HEAD

FIGURE 8–3
Photos Courtesy of Laurie
Steinhorst. Model: Marion
Bonner

3/4 VIEW OF HEAD

- **Position yourself** so that you can see both your drawing and your reflection in the mirror with just a movement of the **eyes**. Avoid having to reposition your head each time you refer to your reflection in the mirror.

- **Prepare your paper.** Prepare a sheet of good quality 18 × 24-inch charcoal drawing paper with a middle value ground. Carry the ground to the edges of the picture plane, creating a smooth even surface of value, void of texture.

- **Begin with thumbnail sketches.** Begin by either creating several thumbnail sketches or by drawing directly onto your prepared surface. If you begin drawing directly onto your prepared surface, treat the drawing as though it were a thumbnail sketch. Work with large general shapes, erasing and redrawing until you have arrived at a strong composition.

- **Use your erasers.** Use vine charcoal or draw with your eraser, erasing lines into the ground. A lot of erasing and redrawing will take place in the beginning of the drawing to *arrive at accuracy in proportions and shape*

FIGURE 8–4
Photos Courtesy of Laurie
Steinhorst. Models: Marbel
Canseco and Ana Santos

 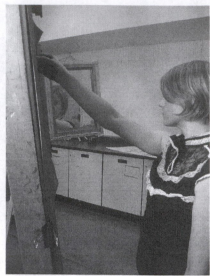

POSITIONING EASEL AND MIRROR FOR A SELF-PORTRAIT

POSITION YOUR EASEL AND YOUR MIRROR SO THAT YOU CAN SEE BOTH YOUR DRAWING AND
YOUR OWN IMAGE IN THE MIRROR. YOUR EYES SHOULD BE ABLE TO MOVE FROM MIRROR TO
DRAWING PAPER WITHOUT HAVING TO TURN YOUR HEAD. REMEMBER TO STAND AT
ARM'S-LENGTH FROM YOUR DRAWING SURFACE.

relationships. Work quickly at this stage of the drawing, concentrating on large basic shapes and working over the entire surface of the picture plane. Don't get distracted with details. Use facial features (corner of an eye, bottom of nose, edge of eyebrow) as landmarks from which to measure and angle. Extend lines from these landmarks using point-to-point methods you have practiced. Drop plum lines from landmarks to help find the relationship of facial feature to facial feature.

- **Make a volumes sketch.** As you work towards proportional accuracy, use line to make a volumes sketch of your head and face that reveals the forms, spaces, and volumes. The only difference between the self-portrait and previous value drawings you have completed in class is the subject matter has changed. Instead of finding the correct proportions of still life objects, negative shapes, and relationship of object to object, you are now drawing your face. Your facial features now become the 'objects' and you are finding the correct proportion of those facial features, negative shapes that exist between features, and the relationship of the features to one another. Refer to the information on proportions of the head at the beginning of this chapter to help you arrive at accuracy. Remember. . . . *eyes are always at the midpoint between the bottom of the chin and the top of the head.* Your volumes sketch should suggest three-dimensional forms in space before you proceed to add value and value gradation.

- **Add values.** Once you have arrived at a strong level of accuracy in your proportions, you can begin adding value with your compressed charcoal. The first step when adding value is to SQUINT your eyes and look at your reflection. Squinting your eyes will clarify the value relationships, allowing you to see the value differences more dramatically and eliminate unnecessary details. With your eyes squinted, locate the darkest dark on your face. Place this black value shape in the appropriate place in your drawing using compressed charcoal. With your eyes still squinted, locate the lightest light on your face. Place this light value in the appropriate

place in your drawing by erasing into the ground. You have now established the lightest light and the darkest dark in your drawing. Establishing these two values that exist at the extreme ends of the value scale will help to ensure a wide range of value in your drawing and can act as a gauge by which you can compare all other values.

- **Add mid-range values.** Now you will begin adding mid-range values, making sure that nothing in the drawing gets as dark as your darkest dark and nothing gets as light as your lightest light. Continue to *compare values to each other*; it is only through the process of comparing and contrasting values that you are able to arrive at the correct value relationships. Use both your compressed charcoal to add darks and your eraser(s) to erase out the lights. Your eraser is a drawing tool, not just a tool to remove your mistakes. (Remember, you can refer to a value-scale to ensure that you have covered the full range of values.)

- **Always work from general to specific,** seeing and drawing the big value shapes first. Continue to squint your eyes as this will allow you to see the overall underlying value relationships more easily. Your drawing will not include every detail on your face. Try to be as objective as possible when looking at yourself, trying to see yourself as though for the first time. Don't assume anything. Take all the information from what you see in your reflection, not what you think you see.

- **Include cast shadows as an important part of your drawing.** Draw cast shadows with as much care as any other object in your drawing. You may have cast shadows from strands of hair falling across your face, eyeglasses, or even jewelry. Let them assist you in creating a sense of form and volume.

- **Be mindful of edges.** Sharp edges indicate a hard-edged, angular form. When edges are hard, take the care to make them crisp and clean. Soft edges indicate a rounded form. When forms are rounded, take the care to make the value gradation soft and gradual. Work toward eliminating any heavy linear outline of forms. The heavy outline of forms only appears to flatten out the form. Instead, let the edges be described by two different values meeting one another.

- **Keep a feeling of volume.** No matter the angle of view you have chosen, *the head is spherical* and your reflected image in a mirror is flat. To arrive at a volumetric feel in your drawing, it is important to remember the three-dimensional nature of the form you are drawing as you bring in the values you see.

- **The larger the value difference, the deeper the space.** Don't forget about the negative space or "background." Negative space has a shape and value that is as important as any other element in your drawing. To create a sense of deep space, exaggerate the value difference between the subject and the surrounding background. If the surrounding background is too similar to the value within the forms it will act to flatten out the overall sense of volume and space. It is better to overstate value differences than to understate them.

- **Step back from your drawing periodically.** Establishing a distance from your drawing offers a different perspective that allows you to see the drawing in another way, picking up distortions and imperfections

FIGURE 8–5
Student self-portrait by
Adam Blejer.
Photo Courtesy of Carla
Rae Johnson

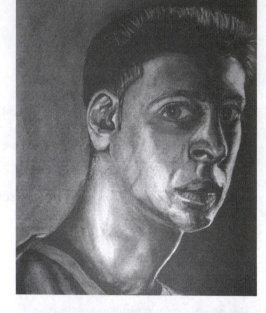

FIGURE 8–6
Student self-portrait by
Andressa Micheletto.
Photo Courtesy of Laurie
Steinhorst

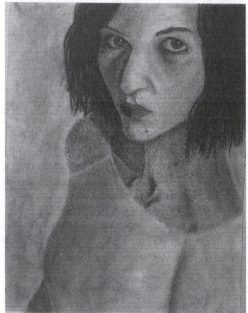

that you cannot see close up. Getting a distance from your drawing is particularly helpful in drawing from life. Any proportional problems will be picked up easily from a distance. Get in the habit of standing several feet back from your drawing every few minutes.

- **Turn your drawing upside down.** Just as stepping back from your drawing can help you to assess the unity and visual interest of your composition, another helpful practice is to turn your drawing upside down on occasion. When your drawing is upside down and you are standing a good distance away from it, you will be able to see the composition alone, without the distraction of recognizable features. From this perspective, you can make decisions about how well the composition achieves a unified whole and maintains interest by visual flow, emphasis, contrast, harmony, and other principles of good composition you have been studying.

FIGURE 8–7
Student self-portrait by
Collin Pressler.
Photo Courtesy of Laurie
Steinhorst

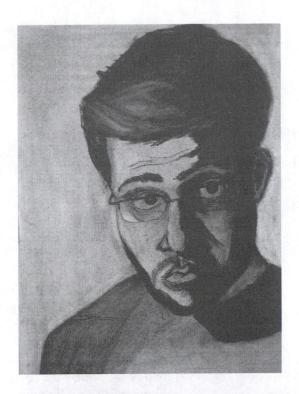

FIGURE 8–8
Student self-portrait by
Tyrone Simpson.
Photo Courtesy of Laurie
Steinhorst

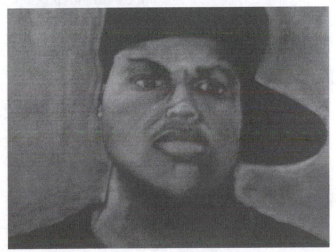

- **Continue to refine your drawing.** As you work into a drawing, your vision will become more precise. As a result you will pick up mistakes that you didn't see at first. Continue to correct your mistakes as you become aware of them, constantly changing and perfecting the drawing.

Don't assess your self-portrait by how much it looks like you. If the objective of the self-portrait was to record only what you looked like, we would simply take a photograph. A photograph depicts a subject at a moment in time and what the subject "looks like" in that split second. Your self-portrait drawing can reveal much more: It can express your mood, your self-image, your power, your vision, your confidence, and even a sense of who you are becoming. The quality of your self-portrait should be evaluated by the intensity of focused concentration that is communicated, the accuracy of shape relationships, the illusion of volumetric space created, and the strength of the composition. These are the qualities that will create a powerful self-portrait. However, if you work slowly and precisely, achieving

accuracy in shape relationships and honesty in your approach, drawing only what you see (and not what you think you see!), you'll be surprised by how strong of a resemblance you can achieve in your self-portrait.

Gesture Drawing

Gesture drawing: An approach to drawing that captures the movement and energy of the form. Gesture drawing is done quickly with fluid lines and is not meant to be "realistic" or detailed.

Gesture drawing is a very different type of drawing than some of the approaches we have discussed in this text so far. Although gesture drawing requires that you continue to observe the subject matter closely, in gesture drawing you move quickly, working to capture the gesture, energy, and movement of the form. Gesture drawings are quick drawings; they can be anywhere from ten-second to ten-minute drawings. They are not meant to be realistic, contain detail, or create the illusion of volume and space. Because of the fast-paced nature of gesture drawing, the process requires you to see quickly and record only the essential information in a pose. Many of the lines in a gesture drawing are imagined lines that flow over and through the form, created to record the dynamic energy of the pose. Although at times the line in a gesture drawing might describe the outside contour of the form, it is only in an effort to continue the energy or a movement, not in an attempt to outline the form. Gesture drawings are done with large sweeping movements of the arm, creating a flowing continuous line, not scribbled or scratchy lines.

Although gestures drawings are often used as a warm-up exercise for a longer figure drawing, they are much more than that. Gesture drawing teaches you to see the figure as a whole, to see the overall movement and the relationship of shapes, and to learn how to capture the feeling of life in the form. Breaking the form into abstract shapes and movements will help you to arrive at accurate proportions.

Procedures for Gesture Drawing – Here are some guidelines you should follow in creating a successful gesture drawing:

- **Use a soft vine charcoal** or soft compressed charcoal to allow for quick, fluid strokes. Hold your charcoal loosely as you would hold a stick, unlike how you would grip a pencil. Work on paper no smaller than 18 × 24 inches to allow you to move quickly with sweeping arm gestures.

- **Stand an arm's distance from your easel.** Your easel should be at a 45-degree angle to the model, making it easy for you to check in with your drawing briefly with a quick movement of the eyes. *Keep your focus on the model.*

- **Do not crop the figure** in a gesture drawing; cropping makes it more difficult to feel the overall movement of the form.

- **Locate the outermost points of the figure first and record them using a simple mark.** For most poses this would mean establishing three points on your paper, one point for the head and one point for the general location of each foot. This will ensure that you get the whole figure on the paper. If you begin with the head then move slowly down the figure, you will run off the paper before you are able to record the whole figure.

- **Observe the overall shape of the pose.** For example, a standing figure with feet apart creates an overall shape of a triangle.

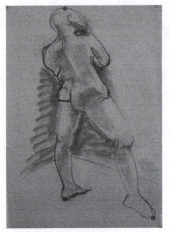

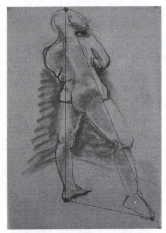

FIGURE 8–9

Gesture drawing with
3 marks recording the outer-
most points on the figure.
Drawing and Photo Courtesy
of Carla Rae Johnson

FIGURE 8–10

Gesture drawing demonstrating
the overall abstract shape.
Drawing and Photo Courtesy of
Carla Rae Johnson

- **Use your whole arm.** When you begin making marks, *use your whole arm, moving from the shoulder.* Imagine the path of an energetic line as it would move through the pose, traveling from head to foot. Your marks should be long flowing lines generated by the movement of your arm. They should not be generated by movement in your wrist, as when writing.

- **Don't be distracted by details.** Such as hair, fingers, and eyes. Instead see the entire subject, looking to record large overall movement.

- **Find the major movements of the pose** by searching for the fundamental structure. Next, find the *secondary and tertiary movements.* Observe how the lines and shapes in the form connect into each other.

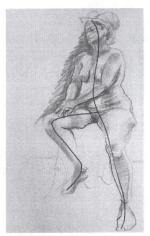

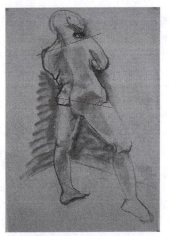

FIGURE 8–11

Gesture drawing
demonstrating the major
movements of the pose.
Drawing and Photo Courtesy
of Carla Rae Johnson

FIGURE 8–12

Gesture drawing demonstrat-
ing the angle of hips and
shoulders.
Drawing and Photo Courtesy
of Carla Rae Johnson

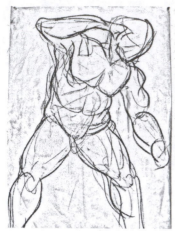

FIGURE 8–13

Student gesture drawing by Adrian Franco. Photo Courtesy of Carla Rae Johnson

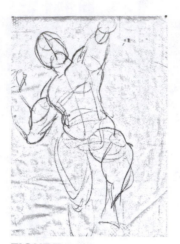

FIGURE 8–14

Student gesture drawing by Adrian Franco. Photo Courtesy of Carla Rae Johnson

FIGURE 8–15

Student gesture drawing by Marbel Canseco. Photo Courtesy of Carla Rae Johnson

- **Do not outline.** Instead draw the imagined lines of energy running through and around the form. At times your line will indicate the outside contour of the form, but it should be in an effort to continue the energy or movement.

- **Suggest structure.** Your instructor may encourage you to suggest the basic forms of skeletal structure in your gesture drawing. Suggestion of skull/head, pelvis, spinal curve, and rib cage can provide an underlying "armature" that supports the volumes of organs, muscles, and flesh.

- **Locate the angle of hips and shoulders.** The hip of the weight-bearing leg will be higher than the opposite hip. The shoulders will most often be angled opposite the hips.

Purpose of Gesture Drawing – A gesture drawing captures the essence of a pose; the end result will not look like a realistic figure. That is not the purpose of a gesture drawing. A successful gesture drawing captures the energy and movement of the form and can appear more like a mass of energetic lines than a realistic figure.

Figure Drawing

Working from the human figure challenges, expands, and sharpens your perception skills in a way that no other subject matter can. It is the reason why artists and art students continue to draw from the human figure. Our innate familiarity with the correct proportions of the human figure requires a visual precision from the artist. When a proportional mistake is made in a figure drawing, our eyes will pick it up right away. This is unlike still life drawing, if lacking knowledge of the actual still life, the viewer is unable to recognize inaccuracies in proportions and shape relationships.

Proportions – Many rules of proportion for the human figure have been developed over time, and a basic knowledge of some of these can be helpful.

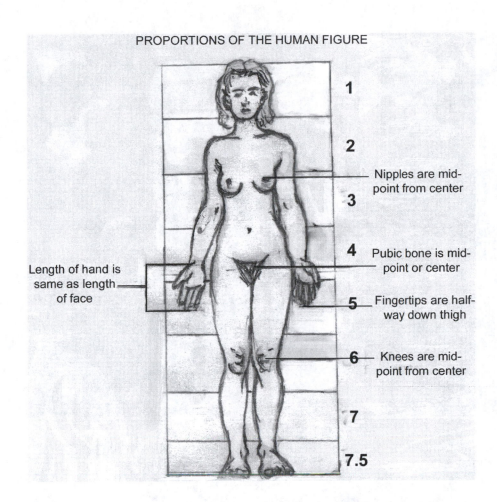

PROPORTIONS OF THE HUMAN FIGURE

Nipples are mid-point from center

Pubic bone is mid-point or center

Fingertips are half-way down thigh

Knees are mid-point from center

Length of hand is same as length of face

FIGURE 8–16
Drawing and Photo Courtesy of Laurie Steinhorst

Keep in mind that there are many different body types. What creates the difference between body types has to do with proportions and relationships of body parts, so these "rules" should act only as general guidelines:

- Height of a full figure is approximately 7½ times the length of the head.
- The pubic bone is the mid-point on the full figure.
- The knees are the mid-point for the bottom half of the body.
- The nipples are the mid-point for the upper half of the body.
- With arms hanging straight at sides, the fingertips would be about halfway down the thighs.
- Length of the hand is about the same as the length of the face. You can test this by putting the base of your palm at your chin and extending the fingers upward to the top of your head. They will touch or nearly touch your hairline.
- The foot is larger than the length of the head. It is often the same length as the forearm.

Many of these rules only apply to a full frontal figure. As soon as the model moves in any direction, many of these rules are no longer relevant. For this reason, the best approach to figure drawing is to use the techniques of visual observation, angling, and measuring discussed in previous chapters and to apply them to the figure.

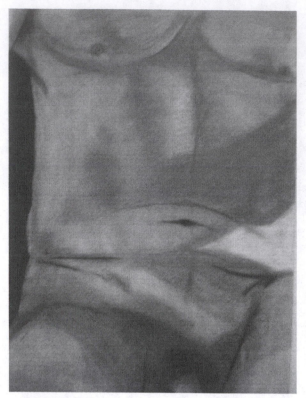

FIGURE 8–17
Student figure drawing by Ashley McDonald.
Photo Courtesy of Laurie Steinhorst

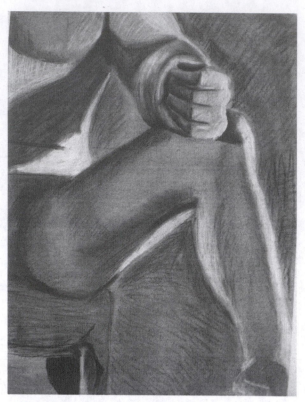

FIGURE 8–18
Student figure drawing by Emily Engler.
Photo Courtesy of Laurie Steinhorst

Procedures for Figure Drawing – Below are guidelines you should follow in creating a successful figure drawing:

- **Remember composition.** As with the other technical approaches to drawing discussed in this book, a good figure drawing begins with a strong composition. When first beginning to work from the live model, don't feel that you have to include the whole figure. Working with just a section of the figure can in fact be beneficial to the beginning student. Depending of the size of the section you choose to draw, you might be drawing the figure life size or even larger. This allows you to precisely observe and articulate parts of the figure that might otherwise be too small on your picture plane to examine. Use your viewfinder to create several thumbnail sketches, working through compositional possibilities until you arrive at a composition that is balanced with dynamic positive and negative spaces. Remember a good composition deals with the entire surface of the picture plane. The figure is just one of the elements that make up the composition!

- **Prepare your paper.** Prepare a sheet of good quality 18 × 24-inch charcoal drawing paper with a middle value ground void of texture.

- **Make thumbnail sketches.** Using the thumbnail sketch as a guide, you will begin your drawing. If you are working with the whole figure, begin your drawing much like a gesture drawing. This approach will help get a feeling of life and energy into the figure and will assist with establishing basic proportions right from the start. Begin your drawing with vine

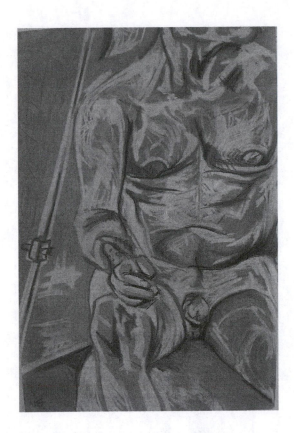

FIGURE 8–19
Student figure drawing by
Natascha Burbridge.
Photo Courtesy of Laurie
Steinhorst

charcoal or draw with your eraser, either of these materials will allow for easy erasing. Be prepared to do a lot of erasing and redrawing at this stage of the drawing until you are able to arrive at accuracy in the proportions. Work quickly, concentrating on large basic shapes and working over the entire surface of the picture plane. Observe and draw the negative spaces. Work general to specific, laying out the foundations of the pose.

- **Make use of the angling, measuring, and point-to-point techniques** discussed in Chapter 5 to help with accuracy in proportions. Use parts of the body (knee cap, nose, navel, nipple) as landmarks from which to measure and angle. Extend lines from these landmarks using point-to-point methods you have practiced. Drop plumb lines from landmarks to help find the relationship of body part to body part. Observe negative spaces; they can be extremely helpful in locating inaccuracies in your drawing.

- **Add values.** Once you have arrived at a strong level of accuracy in your drawing, you can begin adding value with your compressed charcoal. Just as we have been doing with value drawings, the first step when adding value is to SQUINT your eyes and look at the figure. With your eyes squinted, locate the darkest dark in your composition. Place this black value shape in the appropriate place in your drawing using compressed charcoal. With your eyes still squinted, locate the lightest light in your composition. Place this light value in the appropriate place in your drawing by erasing into the ground. Remember negative spaces have values; they might be the darkest dark or lightest light in your drawing.

- **Add additional values.** Begin adding other mid-range values, making sure that nothing in the drawing gets as dark as your darkest dark and nothing gets as light as your lightest light. Observe the values of both the

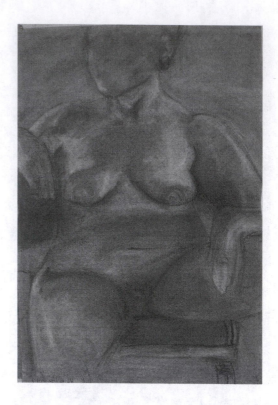

positive and negative spaces. Continue to compare values to each other. Only through the process of comparing and contrasting values can you arrive at the correct value relationships. Use both your compressed charcoal to add darks and your eraser(s) to erase out the lights. Remember, your eraser is a drawing tool, not just a tool to remove mistakes.

- **Always work from general to specific** seeing and drawing the big value shapes first. Continue to squint your eyes as this will allow you to see the overall underlying value relationships more easily. Opening you eyes wide will allow you to see the more subtle value changes. Your job as the artist is to act as an editor, deciding what elements of the figure are significant enough to include in your drawing and what can be left out. Your drawing *cannot* include every detail in the figure. Instead, your drawing need only include the information that will help the viewer's eye read the form and space. Knowing what is important to help the eye read the form and what is insignificant detail comes from experience, bold insights, and experimentation.

- **Include cast shadows as an important part of your drawing.** Draw cast shadows with as much care as any other object in your drawing. Closely observe the shape and value of cast shadows.

- **Be mindful of edges.** Sharp edges indicate a hard-edged, angular form. When edges are hard, take the care to make them crisp and clean. Soft edges indicate a rounded form. When forms are rounded, take care to make the value gradation soft and gradual. Works toward eliminating any heavy linear outline of forms.

- **The larger the value difference, the deeper the space.** Don't forget negative space or "background." Negative space has a shape and value that is as important as any other element in your drawing. To create

a sense of deep space, exaggerate the value difference between an object and the surrounding background. It is better to overstate value differences than to understate them.

- **Step back from your drawing periodically.** Establishing a distance from your drawing offers a different perspective that allows you to see the drawing in another way, picking up distortions and imperfections that you cannot see close up. Getting a distance from your drawing is particularly helpful in drawing from life. Any proportional problems will be picked up easily from a distance. Get in the habit of standing several feet back from your drawing every few minutes.

- **Continue to refine your drawing.** As you work into a drawing, your vision will become more precise. As a result, you will pick up mistakes that you didn't see at first. Continue to correct your mistakes as you become aware of them, constantly changing and perfecting the drawing. Don't be concerned that the eraser marks might be visible. These marks will not appear "messy"; they are instead evidence of the activity and struggle of the artist and can lend an exciting energy to the surface of the drawing.

- **Don't rush.** Creating a strong figure drawing takes time, concentration and focus. Move slowly and precisely, adding details gradually as the drawing develops. The drawing should develop as a whole, not overdeveloping any one area of the drawing more than another. Keep your attention moving all over the picture plane; don't get stuck in any one area. The objective should be to create a sense of unity and wholeness in the drawing. To do that, you must see and draw it as a whole.

Anatomy

To further explore figure drawing, a basic understanding of **anatomy** will prove very helpful. A basic understanding about the muscles and bones that create the underlying structure of the human form will help to give form, weight, and volume to your figure drawings.

Anatomy: The study of the muscles and skeletal system of the human body.

Chapter 9

Concept in Drawing

Using What You Have Learned

As discussed briefly in the Introduction, drawing can be so much more than simply a demonstration of your acquired skills. Drawing can be an effective means of communication and self-expression. In this text you have been introduced to several techniques and approaches to drawing that were designed to build specific skills as well as a basic understanding of composition, value, line, and form. The development of these basic skills can serve as a means to an end. Basic skills and an understanding of the principles of good composition provide you with the facilities by which you can create drawings that communicate effectively and creatively, drawings that act as a means of self-expression. For centuries, figurative artists have sought to imbue their art with meaning in an attempt to communicate.

When artists bring a conceptual element into their drawing, they are attempting to communicate a thought or idea through their work. Whether the intention is to communicate a dramatic experience, deliver social commentary, present an alternative viewpoint, tell a story, or convey sheer playfulness, the artist is working with the elements introduced in this text: composition, value, line, texture, form, and space. Establishing a strong technical base gives you the foundation that will allow for further exploration into the creative and expressive possibilities that drawing can offer.

Generating Ideas and Possibilities

People often ask creative artists, *"Where do you get your ideas?"* The generation of original ideas is a mysterious process, even to artists themselves! This chapter offers some techniques and guidelines that may help you to generate your own original ideas in drawings and to better understand your own, unique creative process.

You may have heard someone say, *"There are no new ideas."* Or, *"There is nothing genuinely new in this world."* Or, *"It's all been done before."* There may be some truth to such statements, but most artists will tell you that it is the quest to discover something new, original, or unique that keeps them going. Pushing to the edges of what you know, as a lifelong mission, may eventually get you to a place that is at the edge of human understanding, which would be a very interesting place, indeed! One of your most significant goals as a student of art will be this quest to explore what you don't yet know. Years from now, you may come across a drawing you made early in your creative life. The drawing may not show the high level of skill you have since developed.

It may not have reached the degree of sophistication in composition of your most recent work. However, you may place high value on the drawing because it contains the germ of an original concept, the suggestion of a unique vision or a fresh perspective. The quest for finding something fresh, unique, and original also motivates those who view, exhibit, write about, and collect works of art. Your skills and strong compositions are extremely important to your success as a student artist, but it is the quality and originality of your ideas and vision that will determine the level of recognition you may eventually receive for your art work.

Where DO good ideas come from? How can you generate lots of interesting, original possibilities? Artists work hard to produce an abundance of possibilities from which to choose. This is because the first things that pop into our heads are usually **clichés.**

Think of idea generation in the same way you think of raffle tickets. If you have just one idea (or ticket), you are stuck with only that one possibility for a winner. If you have three ideas, you have a better chance of choosing something interesting—a winning approach, so to speak. If you have 100 possibilities, think how much better are your chances of selecting something original, something no one else has ever envisioned. With 100 ideas, you have a much better chance of winning BIG!

Techniques

One of the most effective methods used to generate many ideas or possibilities is **creative brainstorming.**

Creative Brainstorming in a Group

Here are the guidelines for creative brainstorming:

1. Set the topic: What is the problem to be solved? What is the idea on which you want to brainstorm?

2. Select someone to be the recorder. This person will write down EVERYTHING that gets said.

3. Set and adhere to a time limit using a smart phone, clock, or stopwatch. Ten minutes is the optimum time for a brainstorm.

4. To begin brainstorming, everyone in the group says whatever ideas come to mind. Fire off ideas as rapidly as they come to you.

5. Do not judge or censor any idea. Do not say "no" to anything that comes up.

6. Push to the edges for the wildest, most bizarre, strange, and unlikely possibilities. The best ideas often exist at the edges!

7. When the time is up, take a break and enjoy the long list of ideas you have generated.

8. Select one or more of the most interesting ideas and do a second brainstorming session to figure out the many ways you could try to realize that idea. This is called a "second level brainstorm."

Clichés: Something overused in popular, everyday culture, like a red heart, a flower, or a smiley face. A cliché is considered "cheap" because it is so abundant and easy to understand.

Creative brainstorming: A technique first developed by businesses and corporations as a means of creative problem solving. Brainstorming can be done by individuals or in collaborative groups. The guidelines for creative brainstorming are listed in this chapter. Essentially, brainstorming is a timed session in which a participant or participants quickly toss out many ideas on a topic, pushing to the edges of possibilities, without making judgments or censoring.

Individual Creative Brainstorming – The guidelines for creative brainstorming by yourself are the same as those above with the exception that you will be recording your own ideas as quickly as they come into your head.

Creative Block

Sometimes you reach an impasse **after you have begun work** on an idea. Artists call such an impasse **creative block**.

Here are some tips that may help when you get stuck:

1. Look around you. Possibilities for the unique and interesting are everywhere! Can you think of an unusual point of view? Can you see through a different lens?

2. Look at everyday objects from a variety of perspectives: from above, from below, from the inside out.

3. Try meditation. Sometimes relaxation exercises will help you focus your conscious mind.

4. Take a nap! The state between waking and sleeping is a fruitful place for the subconscious to kick in and help you generate a unique combination or relationship that your conscious mind has overlooked. (Try not to do this during class, however! To say that you are napping to work on a creative block is not likely to amuse your drawing instructor.)

5. Tap into your emotions. Strong emotions—anger, sadness, elation, even your frustration at not knowing what to do next—can provide a powerful place for original vision.

6. Look through your sketchbook, doodles, idea jottings, poems, diaries, old letters, or e-mails for the germ of an idea or a direction.

7. Try random marks, doodling, or **automatic drawing**. A moving pencil can sometimes find its own ideas.

8. Work on something else for a while. Changing your conscious focus to another task often allows your subconscious mind to work on possibilities while your conscious mind is otherwise engaged.

9. Talk to other student artists. Or engage in creative brainstorm with a child; children are often better at the process than adults!

10. Refer to the work or quotations by your favorite artists. How did they proceed? How did they generate possibilities?

11. Think about your work from another perspective. How would your mathematics professor see this? What would your literature or history class see in this? What relationship is there between what you are doing and what happens in your biology lab? What if your idea were a soccer-ball: where would it go and how would it get there?

12. Don't lose confidence! Don't allow negative statements to creep up on you. Keep your focus positive. Keep in mind situations in the past

Creative block: That uncomfortable time when you are stuck, you don't have any ideas, you can't find a solution to a problem, and it feels like you have "hit a brick wall." It feels as if the door to the creative portion of your brain has been shut or blocked off.

Automatic drawing: A way to experience "free association," which means allowing your mind to jump from one thought to another while your hand follows the thread of thought. In automatic drawing, your hand just moves across the paper without conscious control, much like doodling. The process is almost like the movement of the pointer on a Ouija board. Sometimes recognizable images or objects appear in an automatic drawing. Often the line just meanders in a way that suggests a state of mind, a mood, or a feeling.

when you thought you couldn't do something and then you broke through to a positive outcome. Remind yourself of how good it feels when the solution emerges, or the idea pops into your head. That sense of elation and joy will soon be yours again!

Self-Portrait from Direct Observation

Chapter 8 includes a section on the self-portrait drawn from direct observation. This self-portrait will be a realistic drawing that accurately conveys the proportions, values, three-dimensional forms, and contours of your head and face. The realistic self-portrait drawn from direct observation provides an excellent transition to a self-portrait that conveys more than the purely visual. We call this the *conceptual self-portrait*.

Conceptual Self-Portrait

As a culminating experience in your Drawing 1 class, you will be asked to create another self-portrait. This will be very different from the first self-portrait you drew from direct observation. We call this a conceptual self-portrait to signal that this will be a portrait focused on the "inward" rather than the "outward" self. Your conceptual self-portrait will communicate an idea, express an emotional state, convey something uniquely personal about who you are. This is new territory for most Drawing 1 students! You will apply all that you

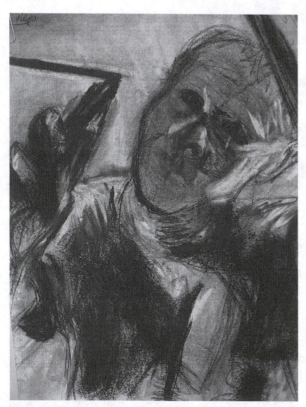

FIGURE 9–1
Student Conceptual Self-Portrait by Adam Blejer
Photo Courtesy of Carla Rae Johnson

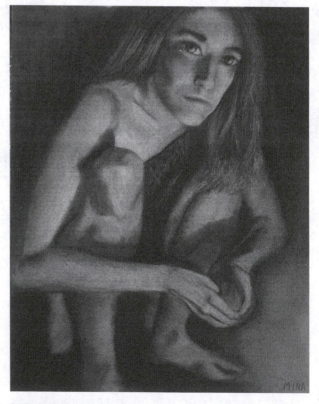

FIGURE 9–2
Student Conceptual Self-Portrait by Marina Mellinas Leva.
Photo Courtesy of Carla Rae Johnson

have learned: your drawing skills, your command of the media and visual elements, and your understanding of the principles of good composition. To these you will also add creative expression and/or the communication of an idea or concept. Your drawing instructor will encourage you to push for a conceptual self-portrait that reveals something uniquely **you**. You will be trying to discover ways to use the visual elements (lines, positive shapes, negative spaces, values, proportions, and textures) that reinforce the expression of your vision. You will also make choices from what you understand of the principles of good composition (balance, repetition with variation or contrast, directional forces or visual flow, emphasis or focal points, and simplicity or economy) to echo and strengthen your message. A strong conceptual self-portrait is one in which the artist has created a unity of elements, principles, and concept with everything working together to communicate the idea, emotion, or message. We call this a unity of **form and content.** In this context, **form** refers to the visual principles and elements the artist organizes, and **content** refers to the idea, message, viewpoint, story, commentary, or feeling the artist intends to communicate.

Don't get discouraged as you wrestle with this task. Artists work their entire lifetimes to resolve and refine the unity of form and content in their work! This is the ultimate challenge, the Mount Everest for every artist. Your conceptual self-portrait may only get you over the first ridge, but the view from there will be so exhilarating you may never want to turn back! It is the ultimate power-trip to succeed in creating a drawing that applies what you have learned while successfully communicating your content. In this case, you are communicating the thing you know most about: **YOU**!

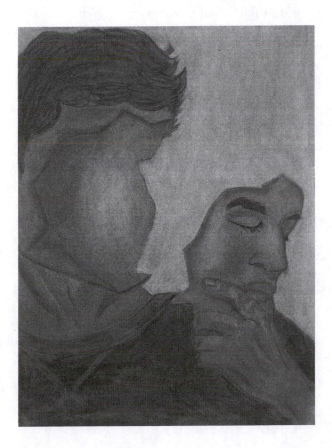

FIGURE 9–3
Student Conceptual Self-Portrait by Aldo Hernandez, Photo Courtesy of Shawn Powell

Individual Drawing 1 instructors will provide you with the specific requirements for your Conceptual Self-Portrait drawing. These requirements may vary a bit from class to class. In some instances, you may be asked to draw a group of objects you select and arrange to create a "still-life self-portrait." Another approach may require you to include some portion of your observed self: head, face, hands, limbs, or body as part of your image. Carefully follow your instructor's directives keeping in mind the recommendations in this chapter for generating an original, unique, and personal vision to complete your drawing.

Sequence for the Conceptual Self-Portrait

Here is the sequence you should follow in creating a successful conceptual self-portrait drawing:

1. Begin by creative brainstorming. With a group of fellow students, with friends, with family, or just by yourself, conduct one or more creative brainstorming sessions that focus on any one of the following questions:
 a. Who am I?
 b. What sets me apart?
 c. What are my greatest strengths?
 d. What do I love to do?
 e. What am I like on the inside?
 f. What or who do I want to become?
 g. What is something very few people know about me?
 h. Do I have a past life? Who was I?
 i. Who/what is my alter-ego?
 j. What was the most important event in my life?
 k. How do I feel when I'm angry, sad, joyful, worried, stressed, hopeful, proud, serene, strong, brilliant, lost, triumphant? (You supply other descriptive adjectives.)
 l. Who is person in history with whom I identify?
 m. If I were an inanimate object, what object would I be?

 You get the idea. Come up with a question **you** think will help get you started.

2. Do some conceptual or visual research. Talk to your friends and family. What do they say are the qualities/attributes that make you unique? Take a poll of the people at your lunch table. Browse in the library. Make a list of your proudest accomplishments. Try online image searches relating to any of the results of your brainstorming sessions. Go through old family and/or childhood photographs. (Note: <u>image searches and photos are not intended as subjects from which to do a drawing.</u> Remember: we **always** draw from direct observation of three-dimensional objects in space. Photos or images on your computer screen are meant to be "prompts" or "points of departure" for your concept. They are intended to help you jump-start your brain on its creative quest.) Whatever you draw must be drawn from direct observation of three-dimensional, real objects in real space.

3. Go to your sketchbook pages. Make sketches and thumbnail sketches of a variety of possibilities.

4. Try some of the tips from the Creative Block section of this chapter.

FIGURE 9–4
Student Conceptual Self-Portrait by Alexis
Bergman, Photo Courtesy of Laurel Shute

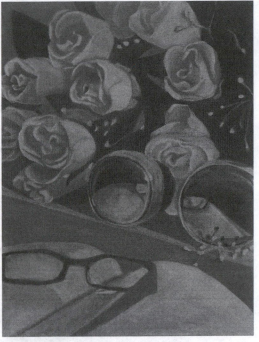

FIGURE 9–5
Student Conceptual Self-Portrait by Guinevere
Alpern, Photo Courtesy of Laurel Shute

5. Once you have decided on the idea, story, emotion, message, in essence, the concept you want for your conceptual self-portrait, do a series of thumbnail sketches that explore possible compositions for the drawing. Remember that the composition (form) must help to reinforce your content. Likewise the shapes, lines, values, textures, spaces, and forms (visual elements) you use in your drawing must also strengthen and echo the content.

6. Follow the sequence given for the self-portrait done from direct observation outlined in Chapter 8, adapting it to the content of your conceptual self-portrait.

7. Your class and instructor may hold a work-in-progress critique. This critique can be an extremely valuable experience, allowing you to articulate your idea and intentions and get feedback from others on how well the drawing-in-progress is shaping up to communicate what you intend. Take notes (mental or written) of everything that is said and apply whatever can help you improve your drawing.

8. Once you have decided your drawing is complete, (wait until <u>after</u> the final critique) spray it with workable, non-toxic fixative to keep it from smearing or smudging.

9. Find a place to hang it so that you and others can view it. Your instructor may select your drawing for exhibition in a showcase or the gallery. Exhibition or display of drawings is an essential part of the learning experience. Receiving feedback from peers, friends, family, strangers, and other artists is crucial to your ongoing progress as a creative artist. Also, if possible, once you take it home, hang your self-portraits where **you** can see them every day. Too often we stash our drawings away after the critique, or after a student show, never to look

FIGURE 9–6
Student Conceptual Self-
Portrait by Edward Sinti.
Photo courtesy of Carla
Rae Johnson

FIGURE 9–7
Drawing by Ricardo
Arcones, Photo Courtesy
of Shawn Powell

FIGURE 9–8
Drawing by Anela Delaj, Photo Courtesy of Laurie Steinhorst

FIGURE 9–9
Drawing by Leopoldo Flores, Photo Courtesy of Laurie Steinhorst

at them again. There is much to be learned from repeated returns to look at your drawings. You may see something you didn't notice as you worked on the drawing. You may find something you'd like to improve. You may find the drawing "grows on you" looking stronger and stronger each day. You may observe something about the composition that bothers you. You may just find yourself brimming over with pride and saying "I can't believe I **did** that!" **Do try** to live with your drawings whenever possible.

Congratulations!

If you've reached this final paragraph of this book and completed the learning and drawing sequence from your Drawing 1 class, you have really accomplished something! You have learned on a very deep level. You have not just memorized some facts or applied some theories. You have built on the learning from the first day, adding more and more sophisticated principles, skills, techniques, and concepts each step of the way. Should you choose to go on with making art, your drawing and observation skills will help you produce better paintings, prints, sculptures, designs, or graphics. Should you end your art experiences here with this course, the skills you have learned can help you in whatever life or career path you choose. Eye/hand coordination, careful observation, principles of visual organization, understanding the human figure, creative thinking, and understanding **yourself** are skills that can give you an edge in any job market or anything you choose to do. Congratulations.

Now, do a gesture drawing of you patting yourself on the back!

Index

Appendices

**VALUE SCALE
(STEPPED)**

**VALUE SCALE
(GRADATION)**

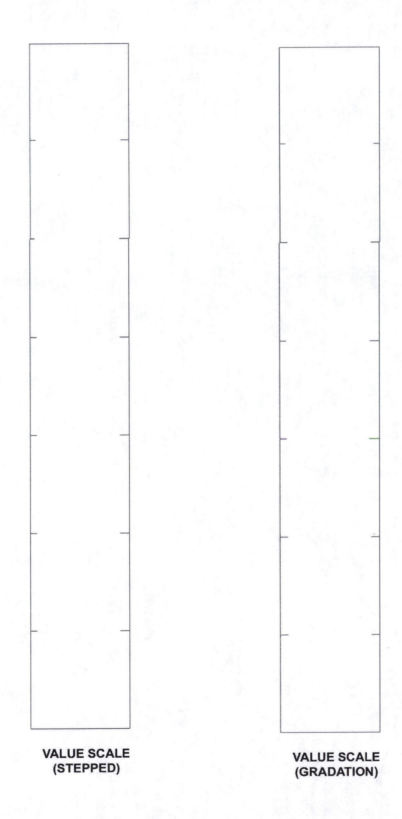

**VALUE SCALE
(STEPPED)**

**VALUE SCALE
(GRADATION)**